LEEK

THROUGH TIME

Neil Collingwood

AMBERLEY PUBLISHING

Acknowledgements

Thanks are owed to Sue Fox; Geoff Fisher & Jean Bratt; Richard Furmston; Stef Callear; Father Michael Bonaccorsi; Samuel Sigley & Sons; Alan Smith; Tanis Pickford and the Staff of Leek Conservative Working Men's Club; Mrs E. Rider; Mr and Mrs Keith Morris; Glynn Thursfield; the Staff of Leek Public Library; Ernie Salt; Alan Pickering; David and Patrick Bode; John Hodkinson; Nigel and Pauline Nixon; Pauline Howlett; Hazel Henshaw; Peak Weavers Rooms and Restaurant; Jonathan Heath of Housey House; Linda Wassall; John Grimes of J&J Greengrocers; Wayne and Gary Salt; Charlie and Fiona Middleton; Norman Goldstraw; Mr and Mrs P. Chevaux.

This book is dedicated to Jean Bratt and Geoff Fisher, whose greeting of 'Hey Mister, want to see some dirty postcards?' always caused smiles to break out in a roundabout way.

First published 2012

Amberley Publishing
The Hill, Stroud, Gloucestershire, GL5 4EP
www.amberley-books.com

Copyright © Neil Collingwood, 2012

The right of Neil Collingwod to be identified as the Author of this work has been asserted in accordance with the Copyrights, Designs and Patents Act 1988.

ISBN 978 1 4456 0839 6 (print)

British Library Cataloguing in Publication Data.
A catalogue record for this book is available from the British Library.

Typesetting by Amberley Publishing.
Printed in Great Britain.

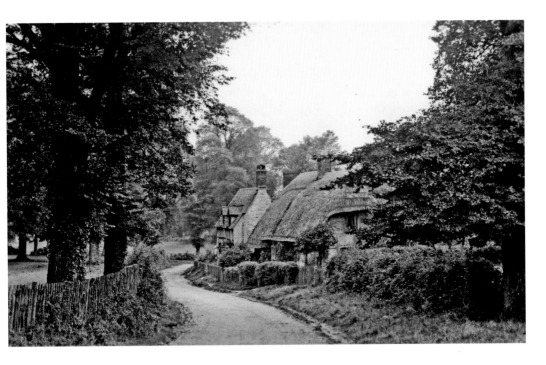

Southam Lane

In our early photograph of *c.* 1900 Southam Lane winds down from the main road to form the picture postcard scene with these two idyllic thatched cottages sitting snugly amongst the elm trees. Dutch elm disease carried away the elms, and, sadly, in the early 1960s a freak tornado struck the village and damaged the cottages beyond repair. Only the line of the road betrays their position, as modern reconstituted Cotswold stone houses stand behind their garden greenery.

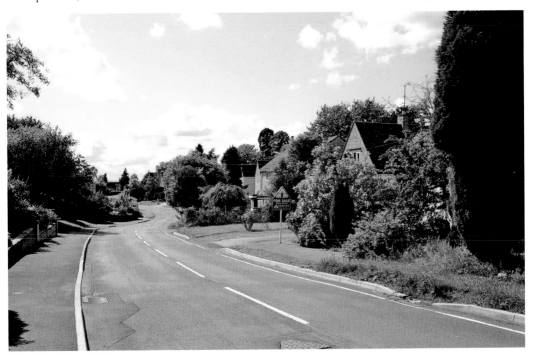

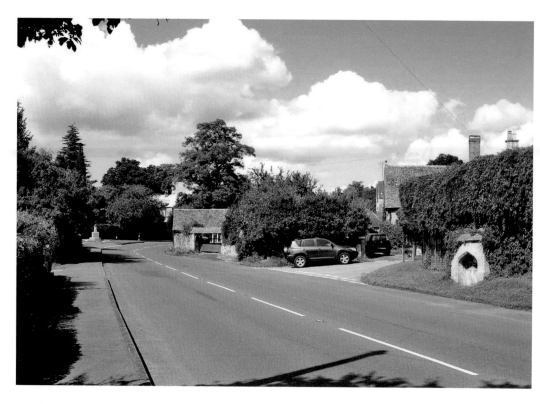

Southam Tram Junction

The double-decker tram is waiting near Villar's Farm for the single-decker from Cleeve Hill. The tram hides a small waiting room. In the hedge on the left stands a stone to commemorate the fatal fall that killed steeplechase jockey George Stevens in 1871. He still remains the only jockey to have won the Grand National five times. The ornate stone cistern on the right was erected in 1846 and restored for Queen Victoria's golden jubilee of 1887.

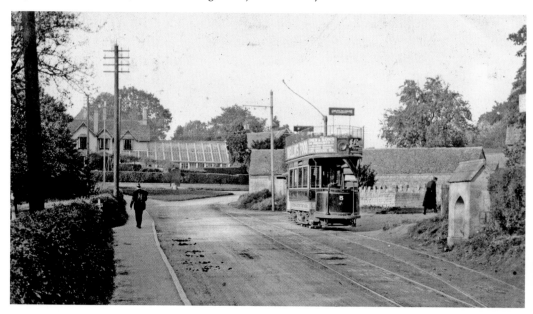

Introduction

When Amberley asked me to compile this volume on Leek, the town of my birth, I was only too happy to accept. There have been many excellent books published about the town already but I was determined to make this title also worth owning and the generous people of Leek have assisted me in this in a variety of ways. They have loaned me photographs, invited me into their houses and allowed me to take pictures from their windows or their gardens. *Leek Through Time* is therefore really a tribute to them, merely put together by me, so a heartfelt thanks to everyone who helped.

Leek is a small market town nestling at the foot of the Pennine chain and watched over by a cluster of millstone grit crags, popular with climbers and Peregrine Falcons alike. These crags, the Roaches – from the French *roches* – rocks – are surrounded by moorland and unimproved pasture, home to increasingly scarce upland birds and until fairly recently a population of Red-necked Wallabies whose ancestors escaped from Roaches Hall, where they had been evacuated from London Zoo during the Second World War.

Leek has been in existence since before William the Conqueror's Domesday Survey was completed in 1086, stating that '*Rex ten Lec*' – the king holds Leek. For half a millennium Leek remained simply a market town, closely associated with the surrounding countryside. Then, in the seventeenth and eighteenth centuries, Leek was transformed by the coming of the silk industry and later by the manufacture of textile dyes. The dye industry benefited from the particular water quality of the River Churnet, flowing through the lower part of the town. Throughout the Victorian period Leek was a major textile town, producing fine silk garments dyed with home-produced dyes, including the best (blackest) black, such as that worn by Queen Victoria during her forty years of mourning Prince Albert. The town also had strong connections with William Morris, who lived here for a time, and other proponents of the Arts and Crafts movement. At its height, a huge proportion of Leek's population was involved in textile manufacturing and this continued until after the middle of the twentieth century. Like the wallabies, though, the mills eventually died out, although many of the actual buildings still stand, awaiting their fates. Leek now has to rely on other industries, including tourism, for its income.

Having already compiled *Newcastle-under-Lyme Through Time*, it is difficult not to compare the two towns. Newcastle was the capital of north Staffordshire in the eighteenth century, remaining independent and influential for generations. Then sadly, in the 1960s the developers

went to work on 'redevelopment'. A ring-road helped traffic to go around the town more easily, and go around it did because that was easier than going *into* the town. Building this road also involved demolishing everything in its way. Then the town 'needed' modernising and so entire rows of attractive and historic buildings were torn down, replaced by unattractive Lego-esque boxes. Newcastle now appears shabby and has no tourist industry to speak of – and so we return to Leek. As I write this introduction, Leek has been gridlocked for months by the roadworks in front of the Nicholson War Memorial, intended to speed traffic to the new supermarket at the edge of the town. The floral roundabout that managed traffic so uneventfully for eighty years, and so complemented our glorious white 'monument', has now been torn up, despite fierce protests, a two-week occupation and an 11,000-signature petition. The newspapers tell us that there are about fourteen more major developments waiting in the wings and yet this one by itself, at this time of deep economic recession, already seems to be having dire consequences for the town.

Leek is an attractive town with a quaint, quiet, old-fashioned charm, the very characteristics that still attract tourists to the many caravan and camping sites, bed & breakfasts and holiday-lets in the area. Many people from the Potteries and other places come to Leek for days out to enjoy the old buildings, the cafés, the markets and the antique shops. It is vital that future developments do not turn Leek into yet another 'clone-town' with shopping centres around the outside, no independent shops and nothing to appeal to tourists. Let us hope that, as in 1986 when a new shopping development was proposed for behind the Market Place, the people of Leek will tell the council in no uncertain terms that enough is enough.

This book is divided into a number of different short sections, focusing on things like the firm of Adams Butter, the mansion houses of the town, transport and churches but, as there would be with any small town, there is much crossing-over between sections and the movers and shakers of leading families like the Nicholsons and the Challinors cannot help but reappear throughout the book.

I do hope that you enjoy this book and will look out for the subsequent volume, *Leek Through the Ages*, due out in 2013.

Neil Collingwood, September 2012

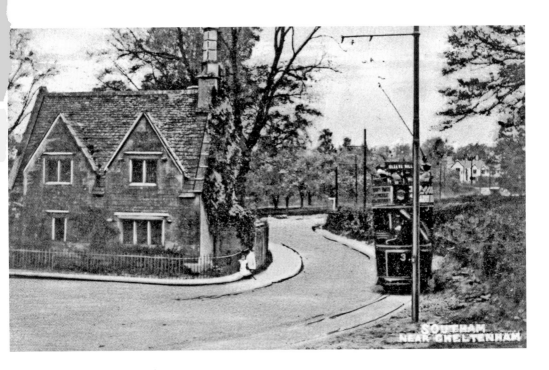

Southam De La Bere Gatehouse

The upper view shows a tram on its way to Cheltenham railway station and also how the original line of the narrow main road swung closely around the gatehouse, where it was joined by the drive to Southam House. In the distance a white finger post can just be made out pointing towards Southam Lane. The village was bypassed in the 1960s and the recent view shows how the original road had to be realigned.

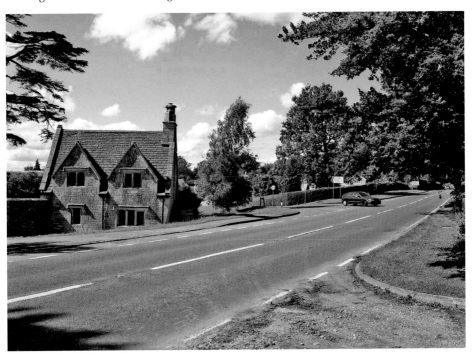

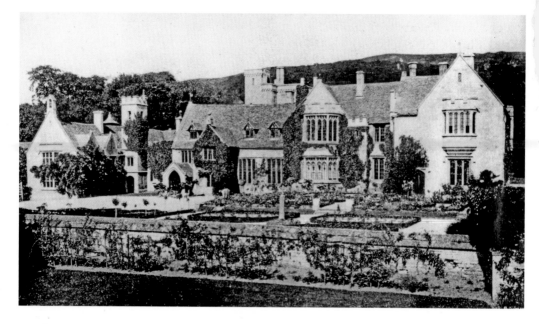

Southam House
Southam House started life as a country retreat for the Huddleston family from Cumbria in the sixteenth century. In 1833 it became the seat of Lord Ellenborough, one time Governor-General of India. In the twentieth century it served as a private school for young ladies and then a hotel, which during the compilation of this volume was undergoing massive refurbishment which explains the lack of a modern image.

Acknowledgements

The basis for this selection of photographs has been our own collections built up over many years. Nevertheless we are indebted to a large number of people who have lent us their photographs and/or given of their knowledge to help us with the captions. So we are grateful to Richard Bearcroft, Martin Coombes, the late Hugh Denham, Ann Evason, Vera Gardner, John Hancock (Australia), Peter Lewis, Alison and Richard Lunt, Margaret Minett, Stuart Minett, the late Bill Potter, Julie Morgan, Eunice Powell, Mollie Quilter, Mike and Sheila Ralls, Graham Teale (Archivist of Gotherington Local History Society), David Waters and Susanne Weir. We have made every effort to trace all copyright holders. Finally we wish to acknowledge the constant support of our wives, Margaret and Loretta. Any faults remain, of course, our own.

David Aldred
Tim Curr

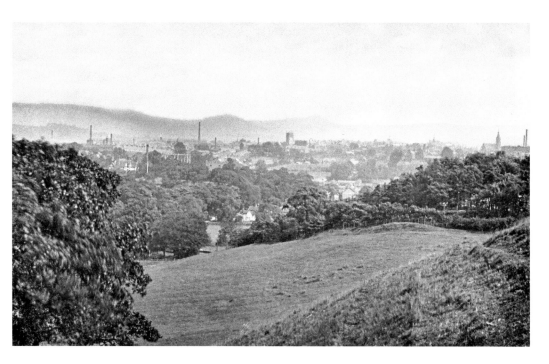

Panorama of Leek from Wall Grange Farm

This old panorama of Leek has St Mary's Roman Catholic church near its right-hand edge and to its left St Edward's church, the gasworks on Newcastle Road and Waterloo Mill. The chimneys of other mills, now mostly demolished, are scattered throughout the town. The foreground of the old photograph consists purely of pasture and woodland, whereas the modern version is dominated by the Adams Foods factory on Barnfields Industrial Estate, where it has been since the 1980s.

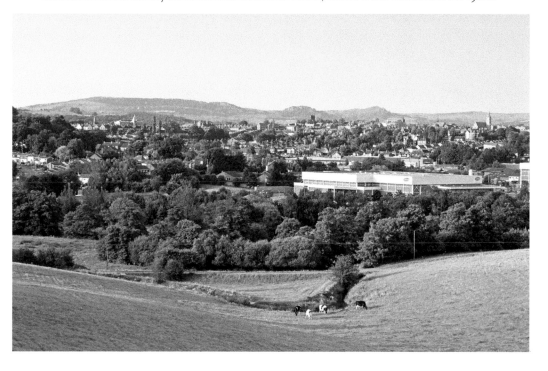

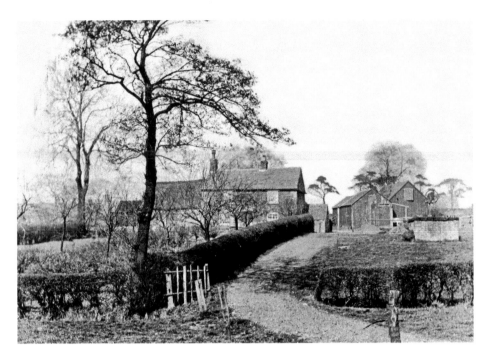

The Adams Family's Springhill Cottage

Fred Adams moved to Leek from Essex in the 1870s and lived at Victoria Street, where he worked firstly as a farm labourer and then a farmer and milk-seller. By 1901 he was living at Springhill Cottage between today's Springfield Road and Buxton Road. Fred's son, also called Fred, began selling pre-packed butter in 1922 and the farmhouse eventually became so surrounded by the 'works' that Mr Adams had a new house built, to the left of the original farm track.

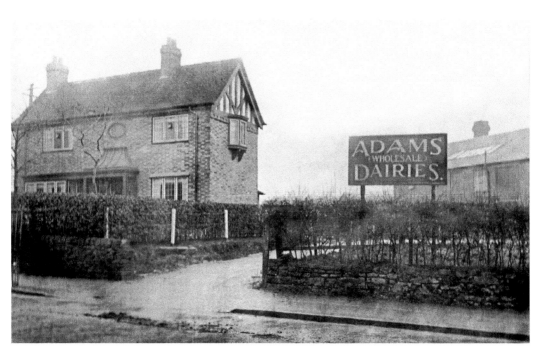

Springhill House and Entrance to Adams' Factory

This old photograph shows the new 'Springhill House' in the 1930s. Across the track can be seen possibly the original sign for 'Adams' Wholesale Dairies' signifying how the company had grown. In the 1970s, Adams became the largest butter manufacturer in Britain and the Irish Dairy Board Co-operative Ltd acquired a majority shareholding. The IDBC Ltd then became the owners before being bought out themselves by Kerrygold. Today the company's base is at Barnfields and the company has returned to its Adams name.

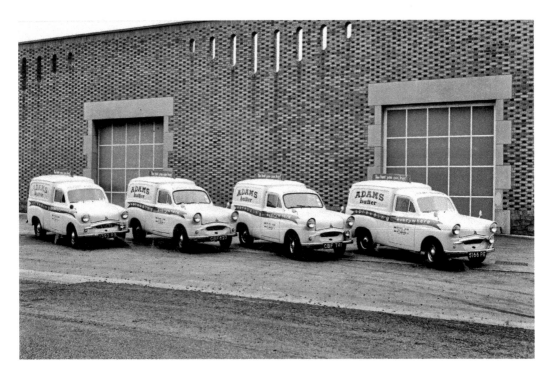

Adams' Standard Rep's Vans, Springfield Road

This Art Deco building on Springfield Road used to house Adams Butter's maintenance garage. It is now occupied by Staffs Fitness, suppliers of gymnasium equipment, as can be seen from the recent photograph. This is the only part of the factory to escape demolition in the 1980s. In the old photograph can be seen four of the 7-hundredweight Standard rep's vans (two different models) from the 1950s. As well as the Leek factory, the vans advertise a London Bridge office address.

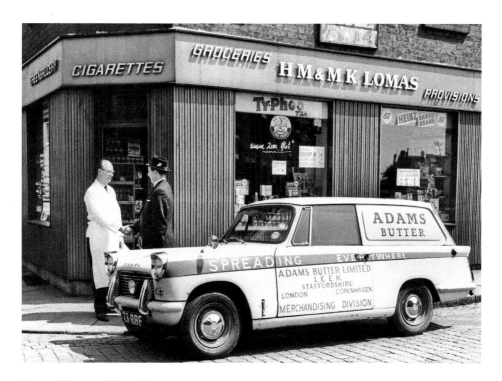

Lomas' Grocery Shop, Grosvenor Street

Lomas' Grocery shop was located at the junction of Grosvenor Street and Moorhouse Street. This clearly staged 1960s advertising photograph shows an Adams Dairy representative paying a visit to the shop in his Triumph Herald van, bearing the Adams logo 'Spreading Everywhere'. This is appropriate given that the van informs us that the firm had already expanded into both London and Copenhagen. Lomas' shop later became a butcher's but like the majority of corner-shops is now a private house.

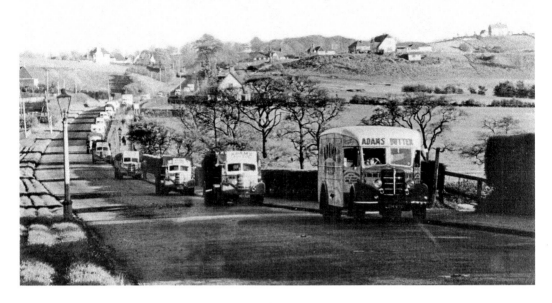

Adams' Bedford Fleet, Cheddleton Road, Birchall

This scene was arranged early on a Sunday morning in the early 1950s, with the Adams Butter Bedford lorry fleet being lined up outside Birchall playing fields. Attempting this today would cause chaos, even on a Sunday, as this is a very busy road, serving as an arterial route to the Potteries and beyond. The scene is now very different, with two large building society offices facing one another across the road and huge volumes of traffic, especially at school-run times.

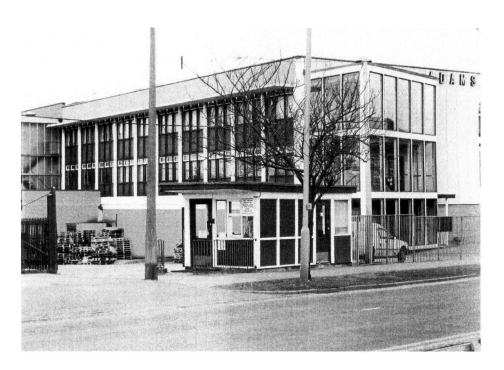

Adams' Office Block, Springfield Road

The Adams office block was built around 1960 and demolished along with most of the rest of the factory in the mid-1980s when the business transferred to Barnfields. The old farm/factory site is now occupied by an Asda supermarket and a compact housing development called Springfield Court. The word 'HALT' can still be seen impressed into the road surface outside the building shown on the previous photograph. This was where the main factory entrance gates, with their porter's lodge, used to stand.

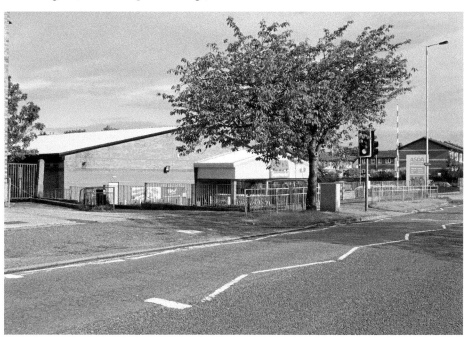

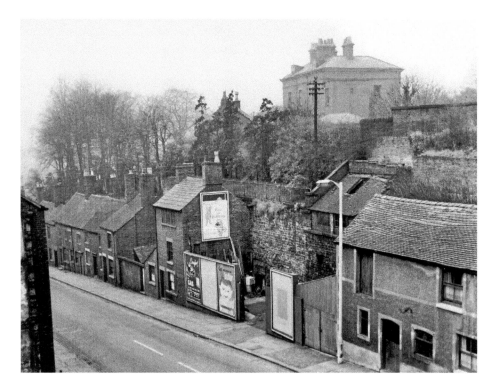

Brow Hill House, 1960

Brow Hill House was built around 1840, possibly for Robert Hammersley, a silk-dyer who was still living there in 1861 with his wife, eleven children and three servants. It was a large house with a lodge and extensive grounds, perched high above Mill Street, as seen in the 1960 photograph. The council bought the house in 1959, intending to convert it to flats, but underestimated the size of the task and so instead demolished it and built council bungalows on the site.

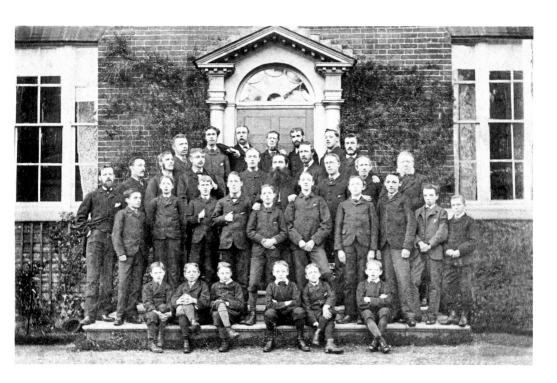

Field House, High Street

Field House, The Field or Fields as it has been variously known, is a late Georgian house built for S&W Phillips, silk manufacturers, and later occupied by the Whittle family, also silk-makers. From 1904 the house had a succession of different uses, including apparently being used as a school, as this old photograph shows. Recently the house has been painstakingly restored for occupation by Millarose Ltd, a ladies' nightwear design company with strong links back to Leek's textile industry.

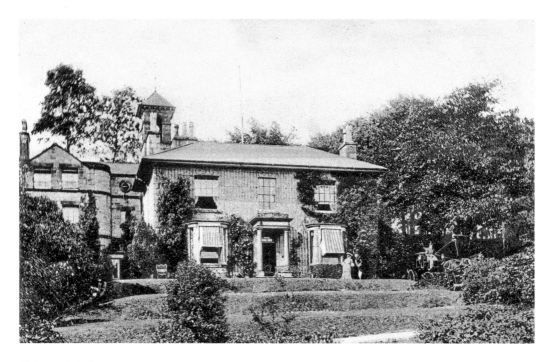

Pickwood Hall

Pickwood Hall was built around 1840, although it incorporates parts of an older building and was extended in 1896 to designs by W. L. Sugden. It was the home of the Challinor family, leading lawyers and philanthropists in Leek for generations. William Challinor, who died in 1896, donated the Challinor fountain and the land for the Pickwood Recreation Ground to the town. Although now very close to a housing development, Pickwood retains its peace and tranquillity, set, as it is, in a beautiful, wooded valley.

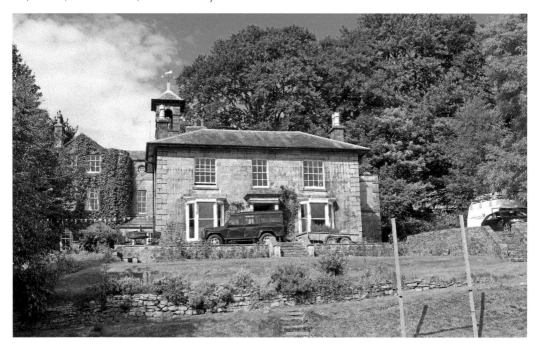

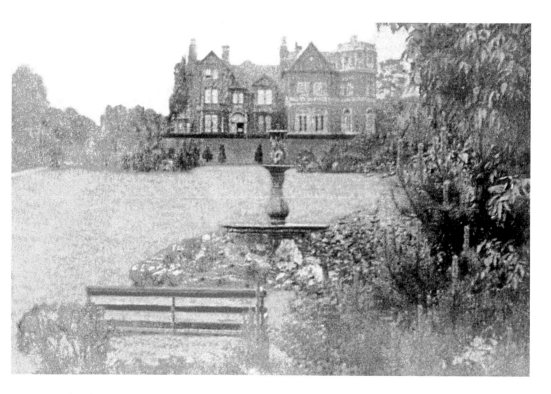

Woodcroft

Woodcroft was a grand house that stood to the left of Newcastle Road on the approach to Leek, although the only evidence for its existence today is in local street-names. It is said that Woodcroft was built for Henry Davenport, manufacturer, and then acquired by William Prince. This may be incorrect as between 1891 and 1901 Davenport and Prince were neighbours, both living at Woodcroft – Prince in 'Woodcroft House'. This possibly covertly taken picture is the only known photograph of the house.

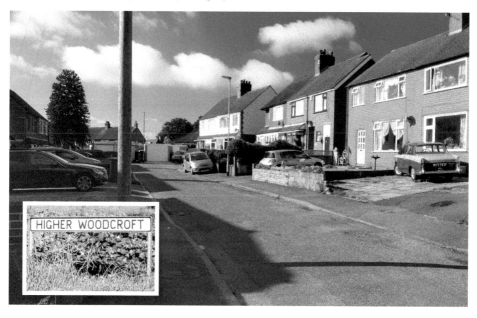

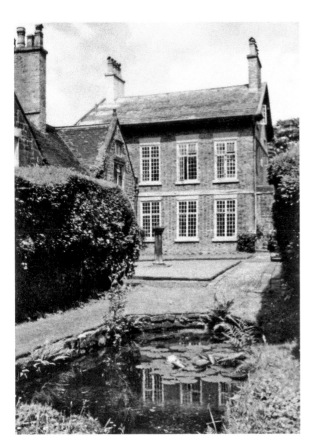

Haregate Hall

Haregate Hall was built in the seventeenth century and was extended in 1722. From 1867 until the 1940s the estate was owned by the Argles family, although for most of the time they lived at their other estate in Westmorland and let Haregate to various local gentry. In 1948 the Haregate estate was sold to the council, who created a different kind of estate there, known locally as 'The Scheme'. One of the roads on this estate was named Argles Road.

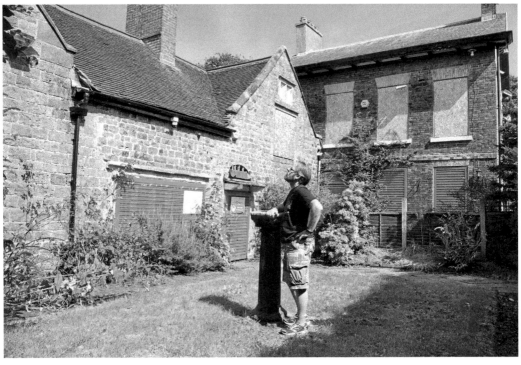

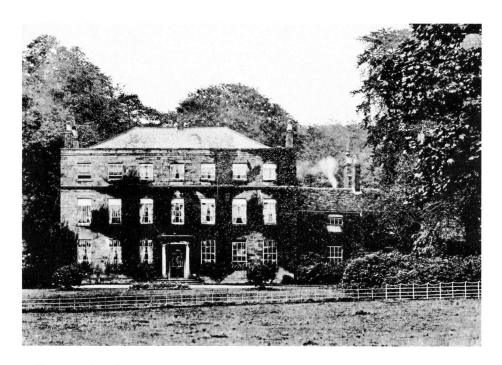

Ball Haye Hall, Built 1797

In 1853 this house belonged to J&J Brough and later to John Hall, all partners in Brough, Nicholson & Hall. As a result many Leekensians refer to it, incorrectly, as either John Hall's or Brough Hall. In the 1930s it was planned to turn the hall into a hospital, but older Leek residents say that money raised for this 'disappeared'. The hall was later converted to council flats but allowed to deteriorate and was demolished in 1972. The site is now occupied by Leek Leisure Centre.

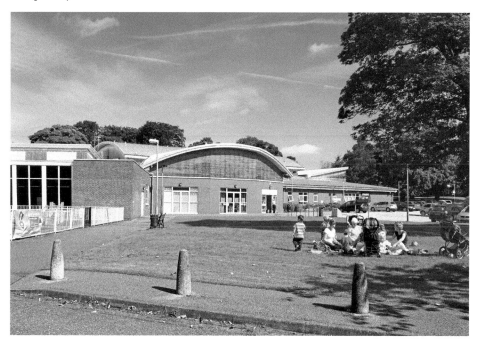

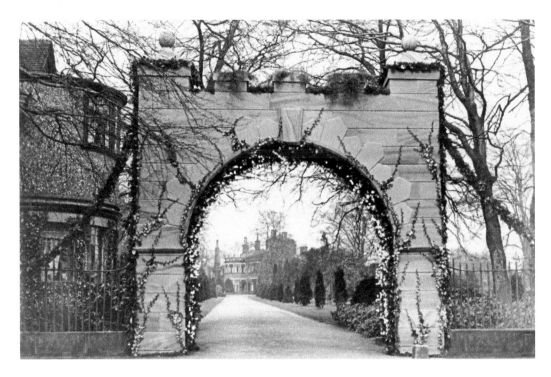

Highfield Hall from Macclesfield Road Lodge

Highfield House, as it was originally called, was built around 1812 in the classical Georgian style, for Richard Badnall, a Leek silk-dyer. The house changed hands several times before being bought by Arthur Nicholson in 1885. Nicholson was knighted in 1909 for his services to industry and public life. The lodge, shown here, still survives in good order but the drive now leads only to three private houses and Leek Cricket Club, the hall having been demolished in 1940.

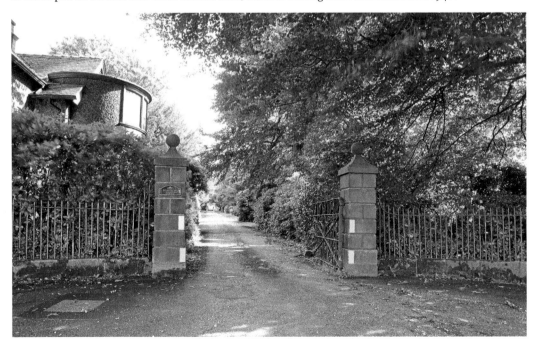

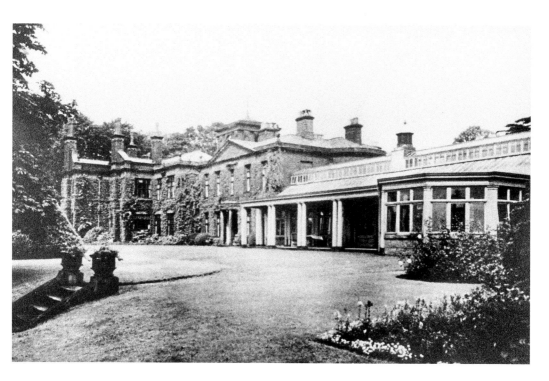

Highfield Hall

Arthur Nicholson extended Highfield soon after buying it and also built a stud farm adjacent, where he bred shire-horses. In 1913, Highfield was visited by King George V, who shared an interest in shire-horses, and Queen Mary. Sir Arthur died in 1929 (see page 58), his wife continuing to live at the hall until her death in 1937. All that remains of Highfield today are the lodge, a few outbuildings and the stables, now converted into Highfield House.

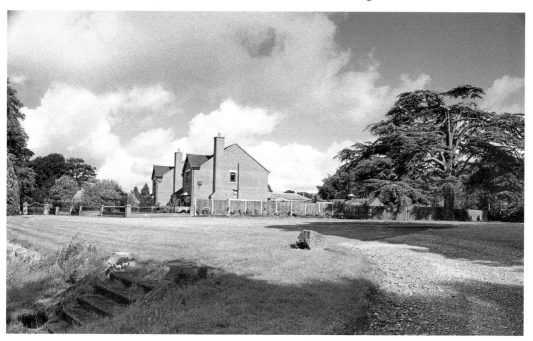

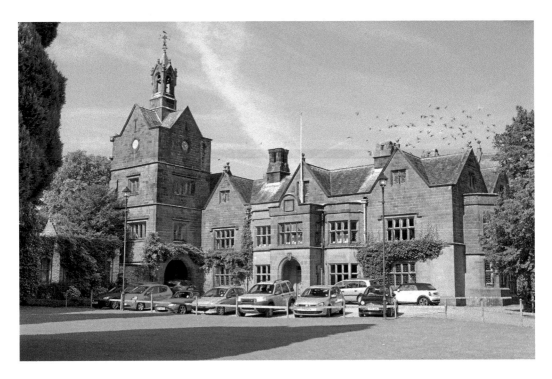

Westwood Hall

The present Westwood Hall is the result of alterations by John Davenport II in 1852–53 to the house he inherited from his father. John Davenport II spent so much on the house that the second mortgage he took out included a proviso that the lender, Robert Brown, should take possession of the hall until the debt was repaid. On Davenport's death his son George redeemed the mortgage but then sold the estate. Westwood became a girls school in 1921 and is today Westwood High School.

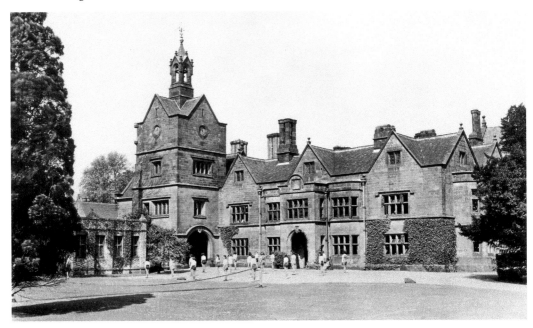

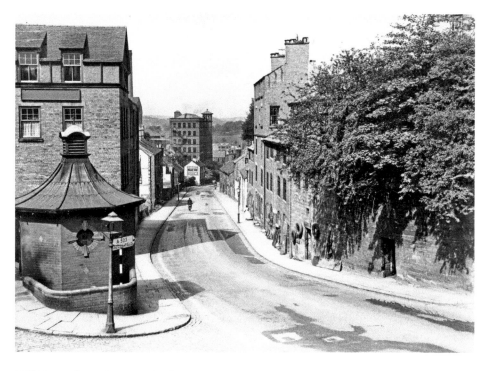

Mill Street from Overton Bank

This superb photograph from the late 1950s shows the view down Mill Street from Overton Bank. To the left are the public conveniences by W. E. Beacham and West Street Club. To the right and left is housing built up against steep sandstone cliffs. Many of the houses had no yards at the rear and extensions or cupboards were obtained by tunnelling into the rock. Presiding over the whole scene was 'Big Mill', designed by William Sugden in 1860. What a different scene this is today.

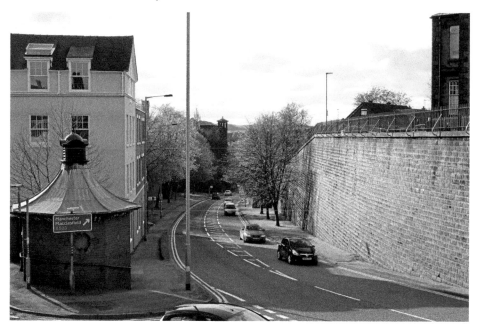

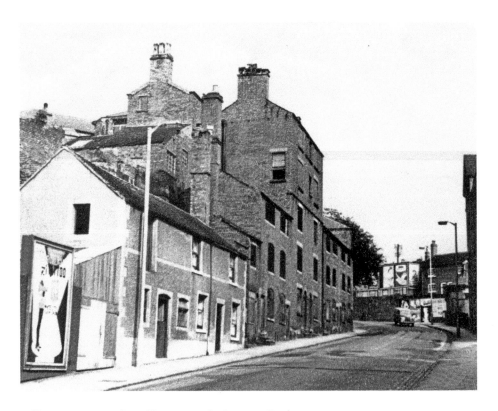

Mill Street, Top End Looking Towards Overton Bank

This unusual photograph is the opposite view from the last and shows just how tall some of the Mill Street buildings were. These tall houses built on the side of hills in Leek would sometimes form two properties, as here, with an entrance to the top floors on one street and an entrance to the lower floors on another. Today Mill Street is a very busy road, likely to become even busier when a new supermarket opens on the Macclesfield Road.

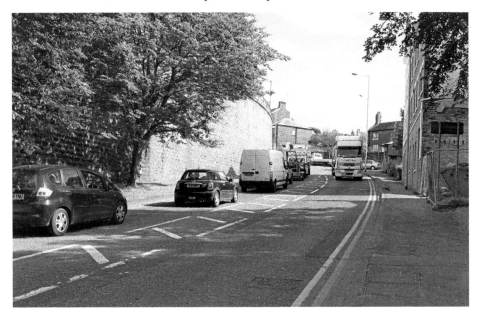

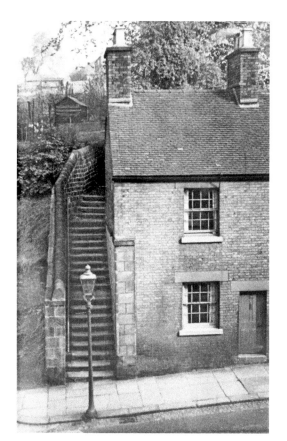

Brow Hill Steps

These steps led from the north-east side of Mill Street up to Brow Hill Passage and thence to the junction of Clerk Bank and Daisy Bank. Today, although the steps are still there, they no longer rise straight up from the road, instead turning through 90 degrees. It is interesting how the house on the early photograph was perched on an existing wall by the steps, thus saving the builder expense for bricks and also allowing the house to be wider.

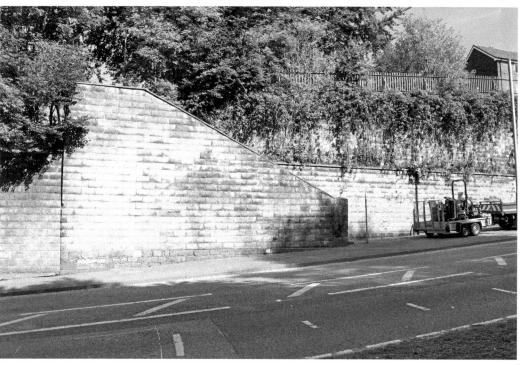

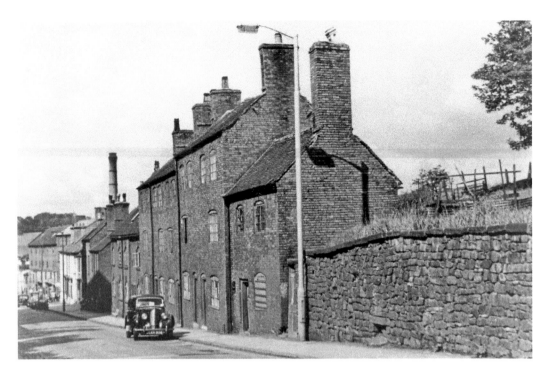

Mill Street Looking Towards the Nag's Head, Late 1950s

On this old photograph the parked car possibly signifies the presence of the last occupants of this block, all the other houses appearing to be boarded up and derelict. Once these residents had moved out, demolition could begin. The white building visible further down the street was the Nag's Head public house, which is today one of only two old buildings surviving on that side of Mill Street between Clerk Bank and Abbey Green Road.

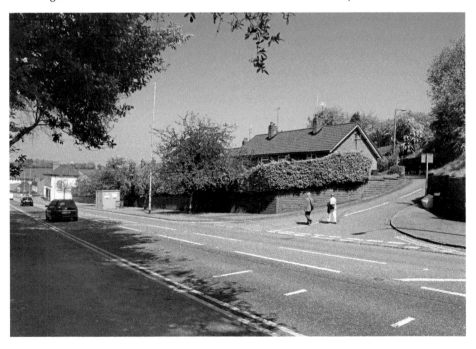

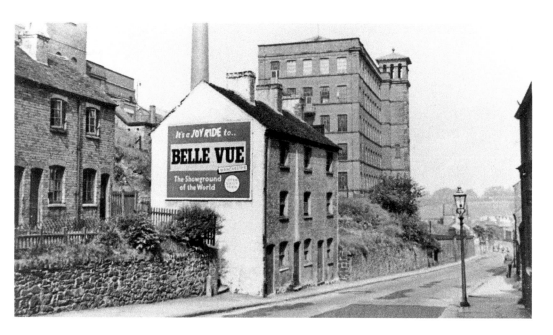

Mill Street and Big Mill, Late 1950s

Possibly taken at the same time as the previous photographs, this image shows part of Wardle and Davenport's huge mill in Belle Vue, since demolished, and also William Sugden's Big Mill, which now stands empty and idle. The poster on the cottages in the foreground advertises Belle Vue in Manchester, then a mecca of tourism. Brow Hill Steps can be seen on the modern photograph and, on the opposite side of the road, though not visible here, are 'Donkey-Bank' steps.

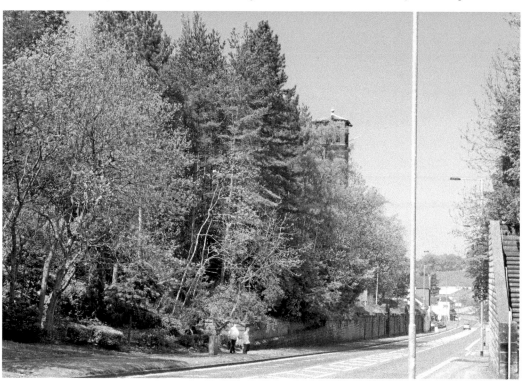

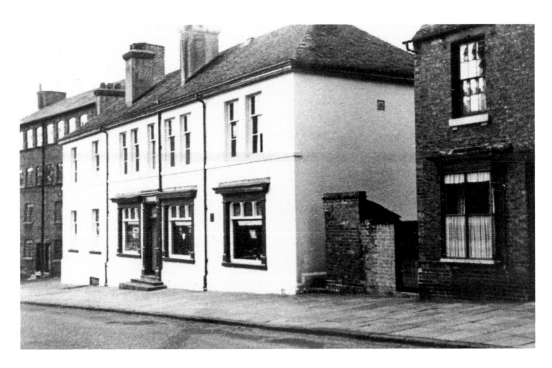

The Nag's Head, Mill Street, Late 1950s

This white building, No. 120 Mill Street, was the Nag's Head, which started life as public house but which according to some older residents served as a 'doss-house' in the 1930s, where people (usually men) could obtain a 'bed' for the night at minimal expense. At the time this photograph was taken it was Ron Deaville's motorcycle shop, and later it sold antiques. It is now a block of private apartments named 120 Central.

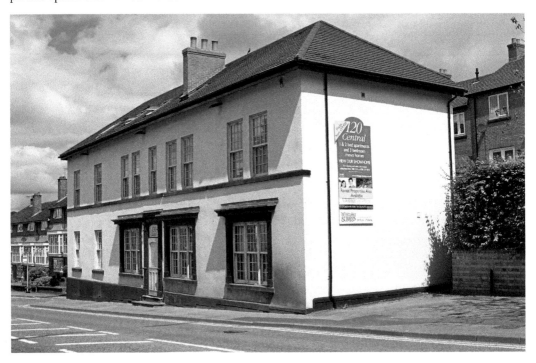

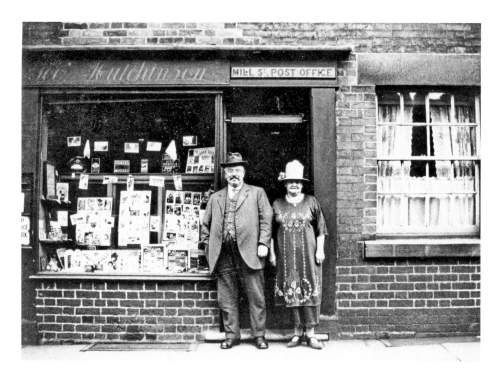

Mill Street Post Office

This unusual photograph is the central portion of a postcard of Mill Street post office, with its proprietors (presumably) standing on the step dressed in their finest. The post office stood opposite the Leek and Moorlands Co-operative Society shop. Next to the window can be seen a post-box with a sign on it directing the public to a police box. In the window are sweets and cigarettes, postcards of Leek and lots of photographs of music-hall stars of the day.

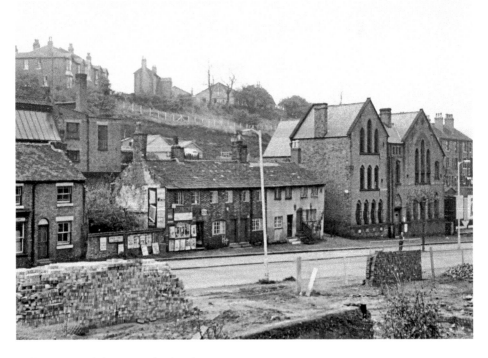

Mill Street and the Ragged School

The chapel and 'Ragged School' were built in 1870–71 to a design by William Sugden. The school closed in 1913 but the chapel remained open until 1990, before being converted into flats. The foundation stones at the base of the wall are degraded, but still visible are bricks bearing the initials of people who contributed to the building. There were once 350 ragged schools providing free education to poor children, but following the 1870 Education Act they were gradually absorbed into the new board schools.

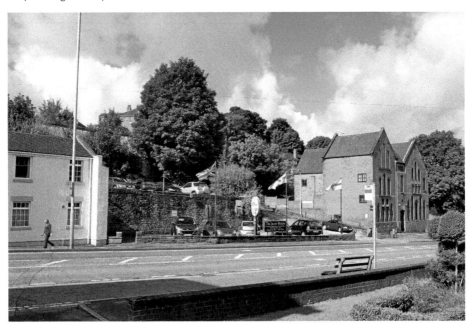

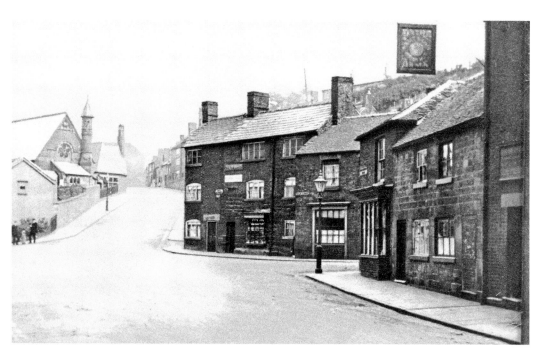

Mill Street, Bottom End

The old photograph shows the junction of Mill Street, Kiln Lane and Macclesfield Road as witnessed by the street signs visible on the building walls. No fewer than four shops are visible in the old photograph, showing that even at this furthest end of Mill Street, shopping would have been easy without venturing out of the community. Today there is one shop and a café halfway up Mill Street, and the next nearest are in Garden Street and West Street.

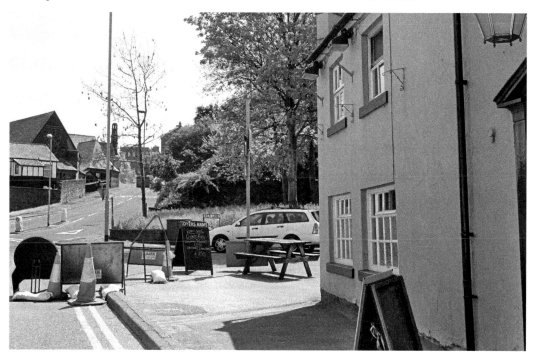

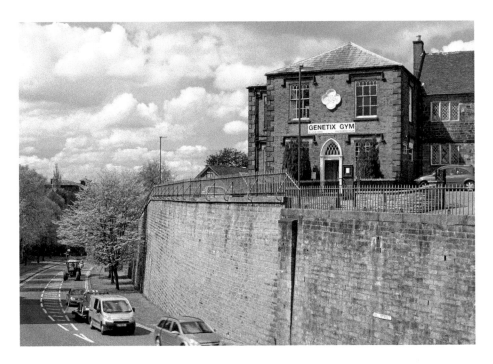

Mill Street During Demolition

This photograph shows the view down Mill Street during demolition of the houses on the right. Perched high above is the Maud Institute, built in 1896, a notice in front stating 'Dangerous Building Operations No Heavy Loaded Vehicles Allowed'. In the sandstone wall can be seen one of many cavities/rooms carved into the stone, which allowed the houses to extend backwards from their otherwise small plots; this one appears to have been filled up with unwanted bricks from the demolished houses.

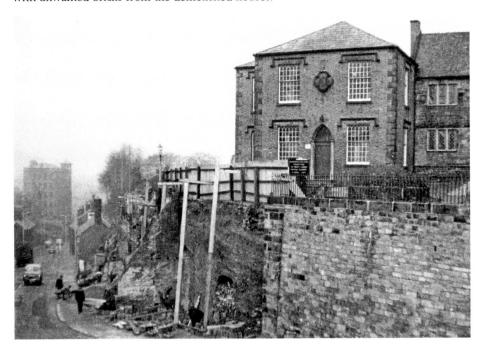

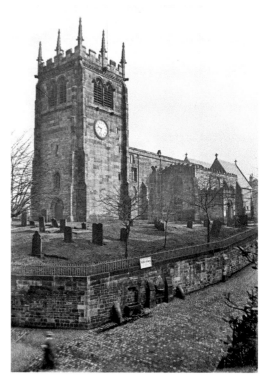

St Edward's Church, c. 1928

This view shows St Edward's church, built after an earlier church was destroyed by fire in 1297. It looks much as it does today except without the war memorial erected at the edge of the churchyard. Trees now largely obstruct the view, making a different viewpoint necessary for the recent photograph. The notice on the railings advertises an Anniversary Men's Service on 24 October 1928 to be given by the Reverend. J. Goodacre. Why, one wonders, should a men-only service be necessary?

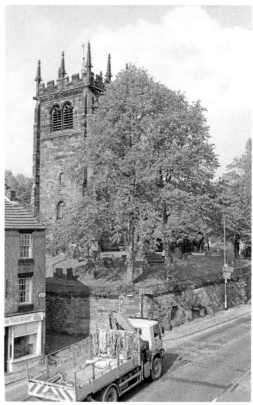

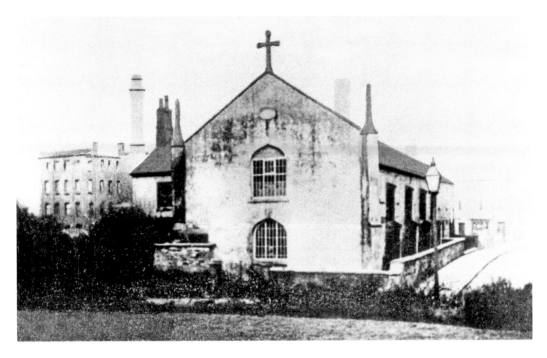

First Roman Catholic Chapel, Fountain Street

Leek's first Roman Catholic chapel was built in 1828 on the corner of Fountain Street and Portland Street. It was demolished in 1864, when the first St Mary's church was opened in King Street. The old chapel was sold and became a silk shade briefly before being demolished and built over, as per the recent photograph. The inset shows the plaque from the old chapel, bearing the inscription 'D.O.M *Deo Optimo Maximo* (to God, best and greatest) MDCCCXXVIII (1828)'.

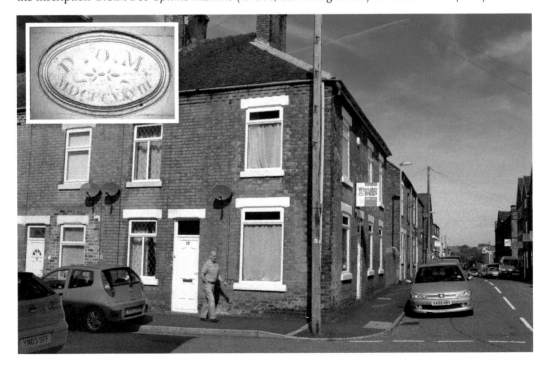

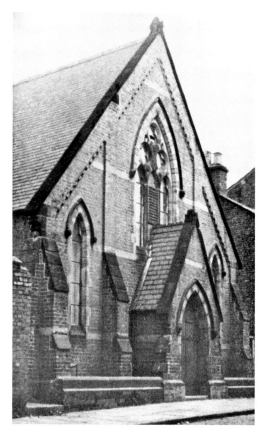

First St Mary's Roman Catholic Church, King Street

The first St Mary's Roman Catholic church was designed by William Sugden and built of brick and stone in a Gothic style. It was in use as a church until the present St Mary's opened in 1887, when it became a school and finally the parish hall. It was in use until the late 1980s and then stood empty until it was damaged by fire in 1994. Today the site is occupied by St Mary's Court, a complex of private apartments.

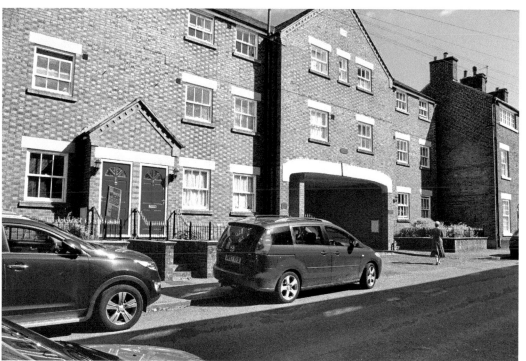

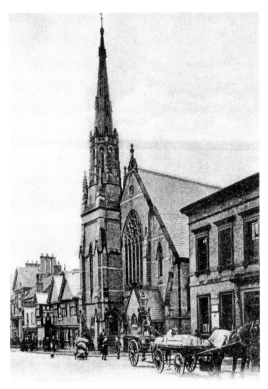

Trinity Church, Derby Street

Trinity church, with its 130-foot-high spire, was built in 1863 in the Decorated Gothic style. It was built on the site of a late-eighteenth-century chapel which had its own graveyard at the front! The decision to build a new church came after the healing of a thirty-year rift in the congregation and William Sugden was the obvious choice to design it as he lived and worked nearby and was also a member of the congregation.

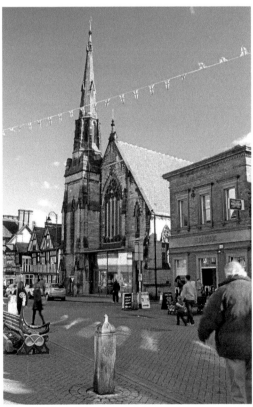

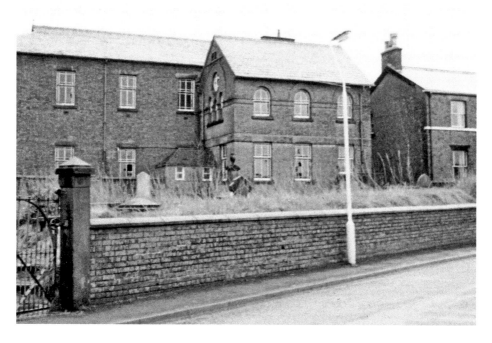

Mount Pleasant Chapel, Clerk Bank

The original chapel, where John Wesley once preached, still stands as Mount Pleasant House, at the right of the old photograph. When the 'new' chapel was built this became the minister's house. By 1979 the chapel had been condemned as unsafe and after demolition the site was sold to the Beth Johnson Foundation, on which they built sheltered housing. Parts of the chapel have been retained in the grounds, as has the graveyard, although sadly the public are not encouraged to visit it.

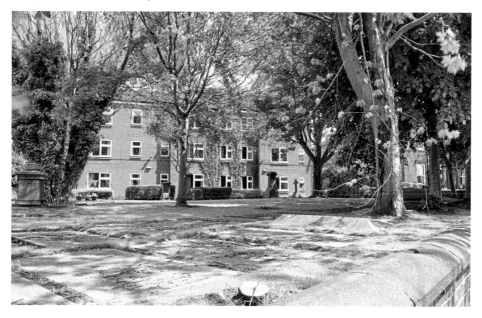

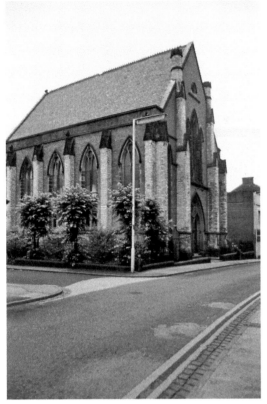

Brunswick Wesleyan Methodist Chapel, Market Street, 1972

The Brunswick Methodist chapel was built in the Gothic style in 1856, once again to a design by William Sugden. It was decreed structurally unsafe in 1976, just four years after this photograph was taken, and demolished the following year. Twelve years later the town hall, which stood directly opposite, was also demolished. Thus, out of the three imposing buildings once standing at the Derby Street end of Market Street, only the Central Club, originally a silk mill, survives.

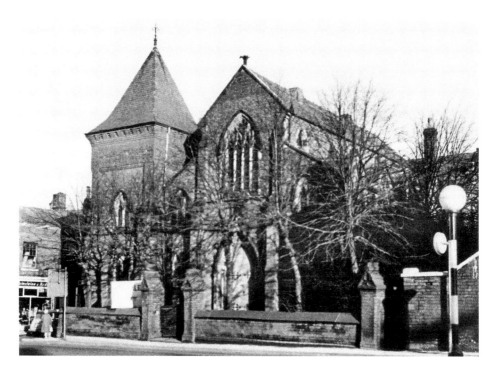

Bethesda Chapel, Ball Haye Street

Built in 1862 for the New Connexion Methodists, this chapel on the corner of Queen Street and Ball Haye Street later became the Bethesda chapel. Having closed once already in the twentieth century, it reopened as a place of worship for a different Methodist denomination but closed permanently in 1963. For a time it became the base of operations for Riley's Recycling, where paper and cardboard was collected for recycling. Demolished in the late 1980s, it is now a car park.

Salvation Army Hall, Salisbury Street

The Salvation Army has had a presence in Leek since 1887 and General William Booth, the Army's founder, preached twice in Leek himself. The hall at the corner of Salisbury Street and Strangman Street, shown in the old photograph, was built in 1936. Following the demolition of the adjacent clinic, that hall was demolished and a new one erected over the site of the old one and half of the clinic site. The new hall opened in 2004.

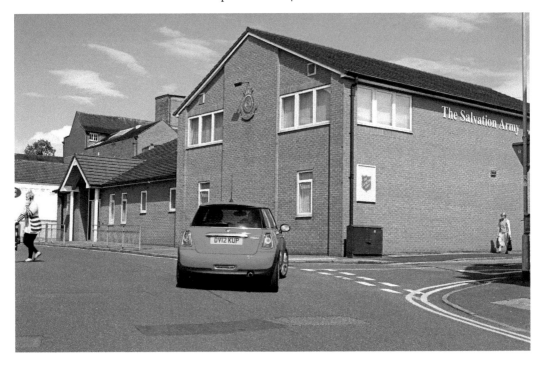

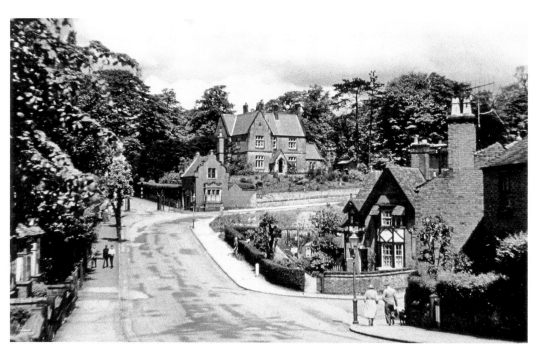

St Luke's Parsonage, Vicarage Road

St Luke's Parsonage was built on a piece of land purchased from the Ball Haye Estate in 1856, the foundation stone being laid on the occasion of Reverend William Dampier's wedding to Sarah Sleigh that year. The building was used by the church until the early 1970s, when a new, smaller vicarage was built in Novi Lane. 'St Luke's House' now houses the Moorland Veterinary Practice, and is obscured from the viewpoint of the original photograph by a screen of trees.

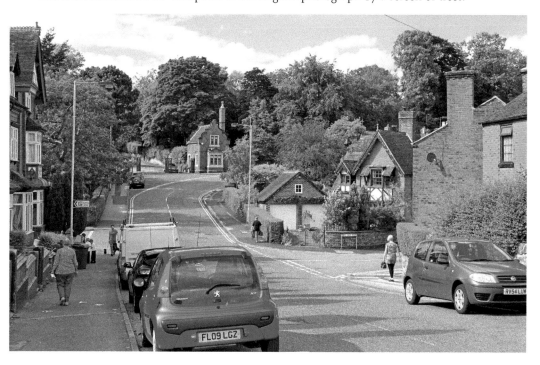

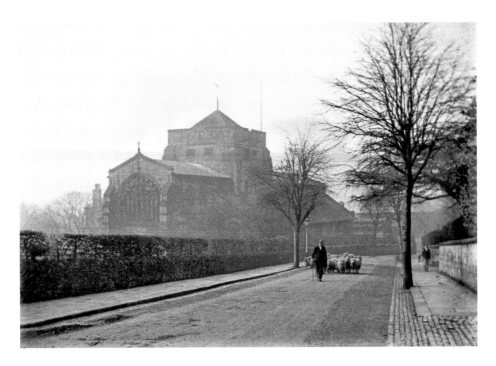

All Saints Church, Compton

The Scottish architect (Richard) Norman Shaw designed All Saints, built in 1885–87, in the Perpendicular and Renaissance style with a central tower. Some consider All Saints to be the finest of the sixteen churches he designed. Shaw considered architecture to be very much an art rather than a science and many of the details of All Saints reflect his support of the new Arts and Crafts movement. Today many enthusiasts visit to enjoy the stained-glass, wall-paintings and embroideries as well as the building itself.

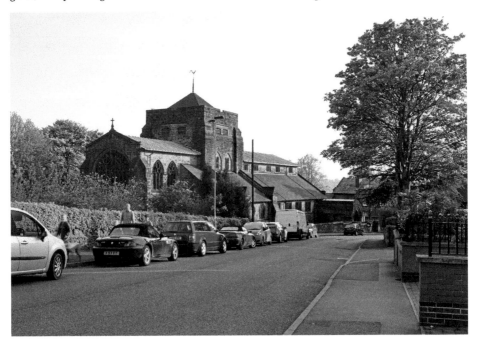

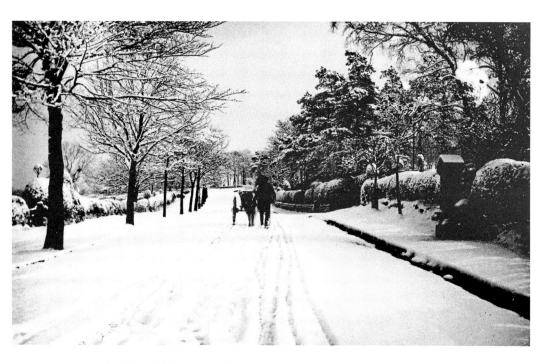

Buxton Road with Drinking Fountain

The drinking fountain known as the 'Buxton Spout' is located where the Ball Brook rises. It was presented to the town by Joshua Brough and bears the now much-weathered inscription *'Pro Bono Publico'* – 'for the public good'. It once provided water to people and their animals but now no longer functions. The Ball Brook is culverted for much of its length but travels through Leek via California car park to join the Churnet at the bottom of Mill Street.

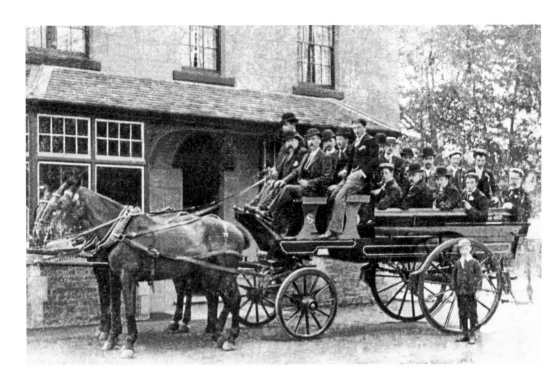

Wagonette Outside Moss Rose, Buxton Road

This wagonette, immediate forerunner of the motorised charabanc, stands outside the Moss Rose pub on Buxton Road waiting to take a party of men out for a day-trip. The wagonette service was operated by Samuel Sigley and Sons, better known today as funeral directors, still operating from Queen Street. Samuel's work always revolved around horses as he was a coachman/groom in 1891, a livery stable and coach proprietor in 1901 and a livery stable-keeper living in Field Street in 1911.

Walter's Saddlery, Broad Street
This highly unusual building is situated near to the junction of St Edward Street and Broad Street. Sadly the heavy wooden pillars to either side of the frontage and the fancy roof-tiling above the upstairs windows visible on the old photograph have now been removed, but the building remains eye-catching, having been carefully restored to its present state. Formerly an antique shop and a launderette, the shop is now 'Housey House' and sells diverse gifts, including novelty resin animals, like gorillas and sheep.

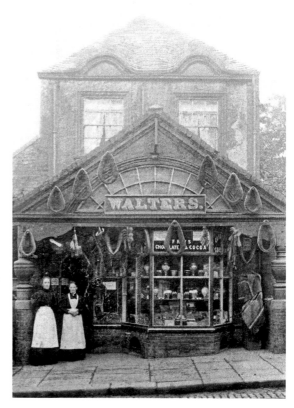

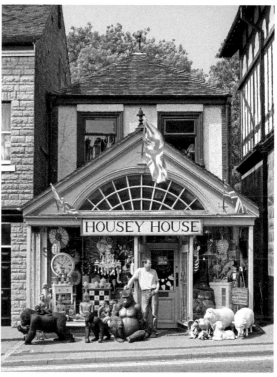

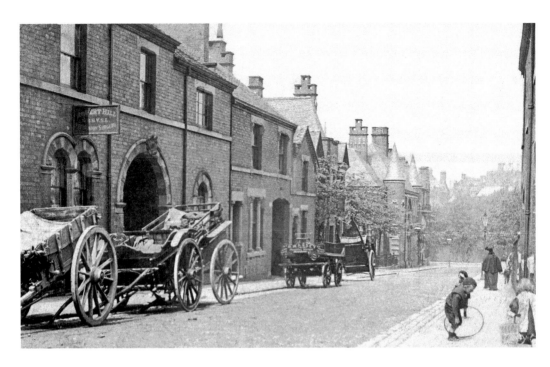

Robert Hill's Veterinary Practice, Leonard Street

When horses were the main means of transport, a range of tradespeople were required to care for the animals. In Leonard Street, Robert Hill's veterinary surgery operated from inside an archway surmounted by a stone-carved horse's head. The head still survives (inset) although the vet's is long gone, replaced by Tylman's cabinet-makers and kitchen-fitters. Hill seems to have done well for himself, as by the age of fifty he had fathered at least six children and retired.

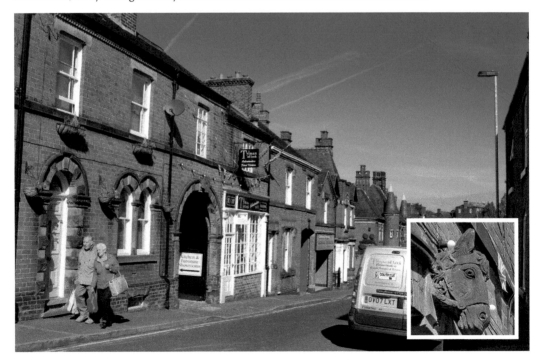

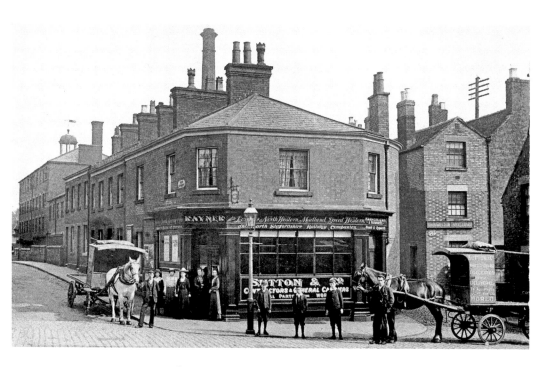

Rayner's, Stockwell Street

This property, today occupied by Blakemore & Chell, was occupied around 1908 by Rayner's and Sutton's, who would today be said to be involved in 'transport logistics'. In those days though, sisters Annie and Catherine Rayner were 'rail parcel agents' and Sutton's were general contractors and carriers, delivering via horse-drawn vehicles to 'All parts of the world'. Hmm! Perhaps even slightly more bizarre was the fact that harmoniums and pianofortes could also be tuned and repaired at these premises.

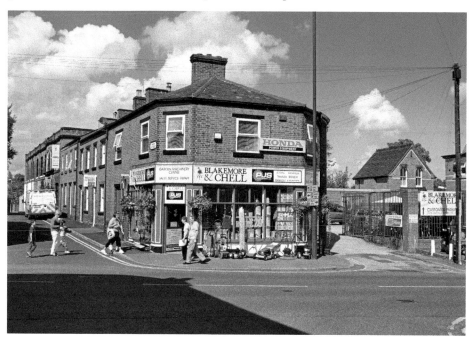

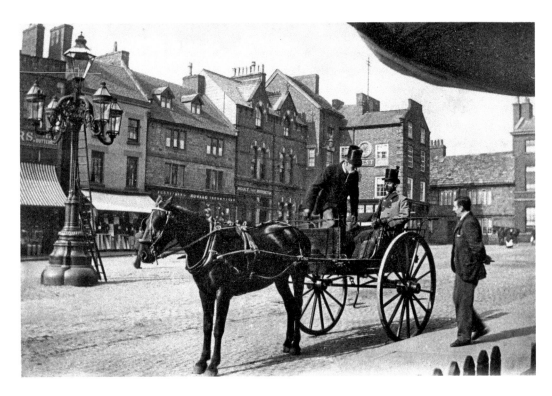

Horse-Drawn Trap, Market Place

This old photograph appears to show the horse-drawn equivalent of a Roll's Royce disgorging its gentleman passenger at the Red Lion in Market Place. Both passenger and 'driver' are immaculately turned out and the passenger's moustache has plaited ends that extend fully 6 inches downwards past his chin. In the background is Robert West's watch and clock shop (demolished around 1930) complete with the clock that West provided for public convenience. This clock's duty is now performed by the one on the Butter Market.

Collecting Horse-Muck in St Edward Street, *c.* 1900

This post-1897 view down St Edward Street towards Compton shows two horse-drawn traps and a scavenger's handcart. 'Scavenger' has various meanings but here refers to a person employed to remove rubbish and 'hoss-muck' from the roads, something he appears to be doing with an implement similar to the snow-scoops sold in supermarkets today. When you look at the amount of horse manure on some old photographs, it is easy to see how essential this service was.

Newcastle Road Before Burton Street, c. 1905

This old photograph, like the one of Woodcroft, is one half of a small stereoscopic pair, hence its relatively poor quality. It shows the view from Broad Street to Leek railway station and Newcastle Road beyond. The most interesting detail is that opposite Junction Road, Burton Street has not yet been created. The bridge carrying Newcastle Road over the railway can be seen in the distance. This was replaced in 1950–51 because, surprisingly, until then it actually contained a large amount of wood.

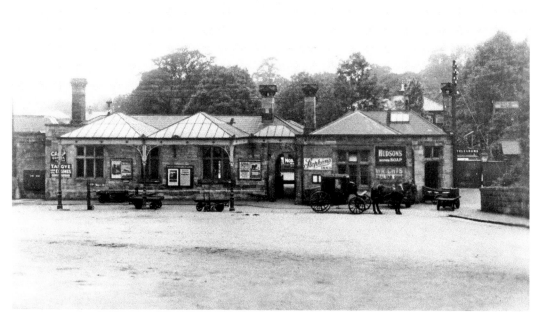

Leek Railway Station

July 1849 saw the arrival of the railway in Leek, where a station was built by the North Staffordshire Railway. The company also acquired a house next to the station and converted it to the Churnet Valley Hotel. The station was rebuilt in 1880. Passenger services to Stoke and Macclesfield ceased in 1960, before Dr Beeching's infamous cuts, although freight continued to be carried. The station finally closed to all trains in 1970 and was demolished in 1973.

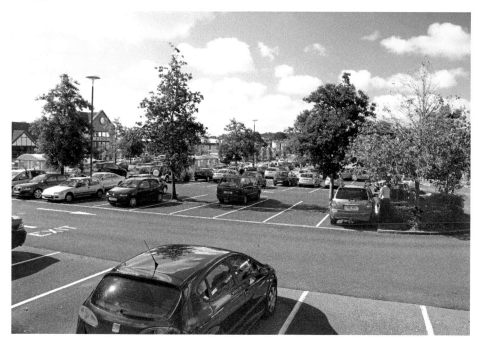

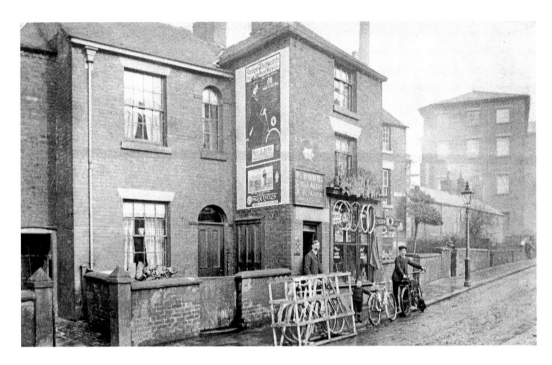

Bode's Cycle Shop, Ashbourne Road

This shop belonged to Ferdinand Bode, born in Leek and the son of a German immigrant shoemaker called Charles. Ferdinand was a mechanic's apprentice in 1891 but by 1911, after a spell in the army, he was back in Leek as a textile machinery fitter. He established his shop soon afterwards and this photograph must have been taken between then and 1927, when Singer ceased making bicycles. Later the building became Hodkinson's garage, site of a fatal petrol-tanker accident. The building now stands empty and roofless.

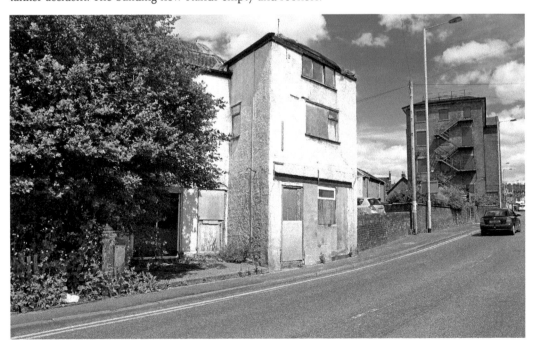

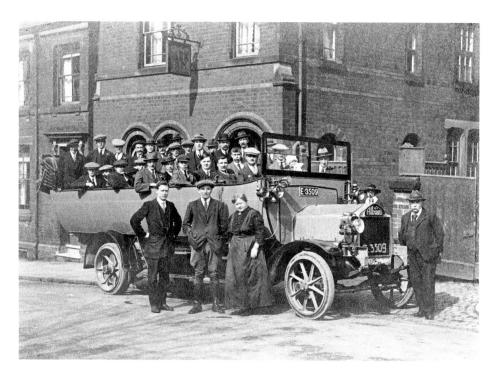

Charabanc Outside the Park Inn, 1911

This old photograph is believed to show a group of men ready to embark on a trip to the 1911 Cup final. Standing from right to left: Mr William Stubbs, publican of the Park Inn; his wife, Harriett; the driver, Bill Magnier; and Charles Gell. Charles was Harriett's son by her first husband, John Gell, who until his death was landlord of the Bull's Head in St Edward Street. It would have seemed a very long journey to London on solid tyres.

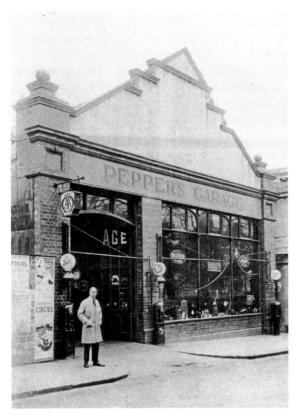

Pepper's Garage, High Street
The first Pepper's Garage was established in Hanley in 1902. Those premises were enlarged and the firm went from strength to strength, buying and building other branches, including this one in High Street, Leek. The premises in the photograph were purely for repairs but by 1965 had been enlarged to include a new car showroom. A series of takeovers resulted in the Pepper's Motor Group being broken up, and in Leek the building became a Kwik-Fit exhaust centre before being demolished.

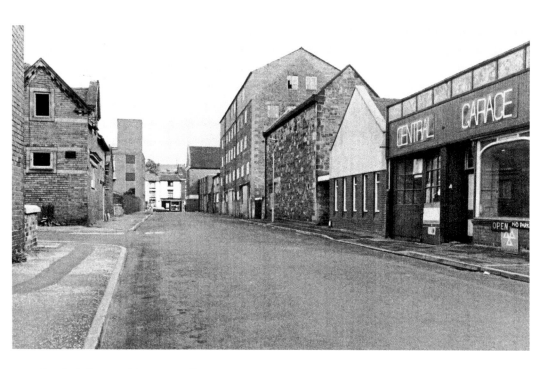

Central Garage, Strangman Street
This photograph looking towards St Edward Street shows Central Garage, already closed and awaiting new occupants. Today it is the home of 'French Finds', who source and sell French antiques. Beyond the garage is what used to be a small chapel, and then a stone building once occupied by Sigley's, the undertakers. The large building beyond is Whittle's corn mill. They did not limit themselves to only selling flour, oatmeal, etc., but also cement and fertilisers and they were even agents for Ind Coope Ales!

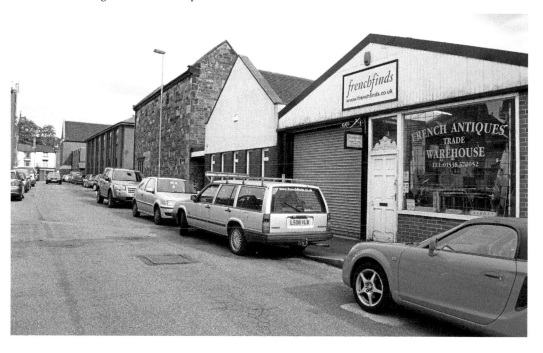

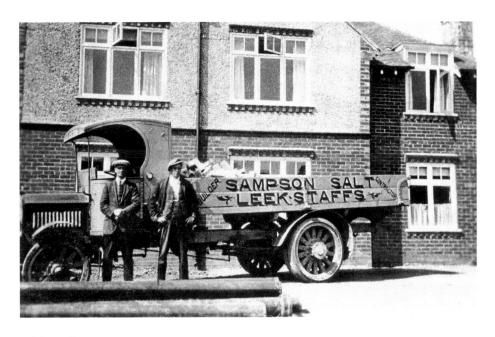

Salt's at The Crescent

Sampson Salt's building firm was responsible for building the Palace Theatre and Grand Theatre and Hippodrome in High Street after land belonging to Field House was sold off. Salt's also built large parts of Haregate, known locally as 'The Scheme', when the Haregate Hall estate was sold. Both photographs here were taken outside the same house in The Crescent, Haregate, where Sampson's great-great-grandsons can still sometimes be found carrying out building work. Their firm now goes by the name J. S. Salt & Sons.

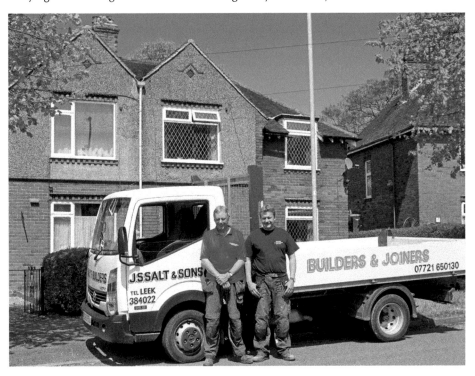

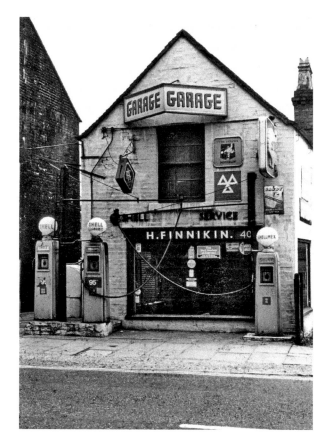

Finnikin's Garage

This photograph shows Harry Finnikin's Garage just after the old showroom was vacated in favour of the present much larger one. The old petrol pumps were also replaced by new ones under an all-weather forecourt. Today Finnikin's no longer sells petrol and instead specialises in selling and maintaining Skoda cars. The garage is run today by Ian Salt, son-in-law of the previous owner, Norman Ainsworth, although Norman still works there three days per week.

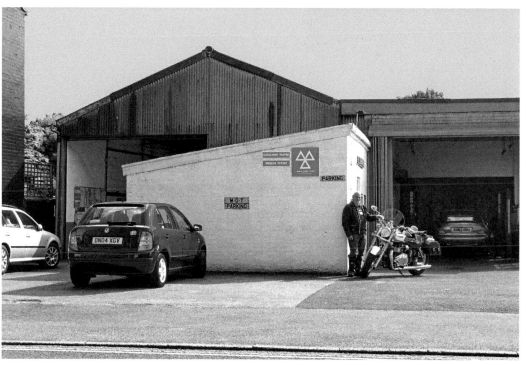

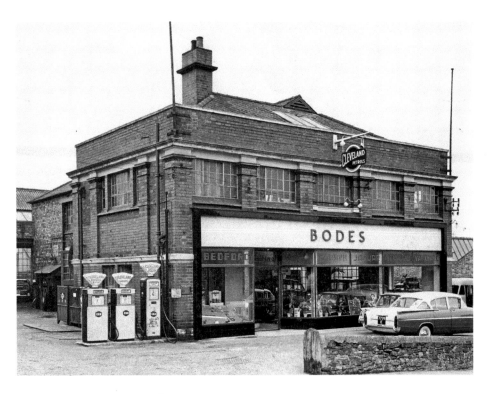

Bode's Garage, Buxton Road

The Bode family moved onwards and upwards from bicycles (see page 50), to motorcycles and ultimately to cars. They also produced industrial machinery from their works in Ball Haye Green. Although both Bode's Garage on Buxton Road, pictured here, and Bode's Engineering closed down around 1990, Ferdinand Bode's grandsons David and Patrick still exercise their mechanical skills in workshops at the rear of the former garage, while the remainder of the premises are rented out.

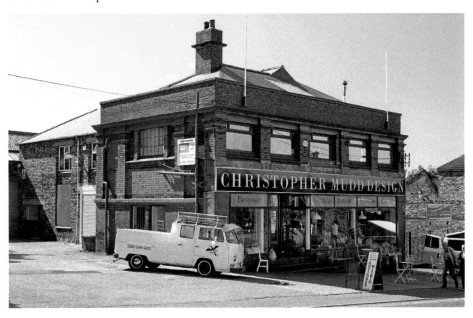

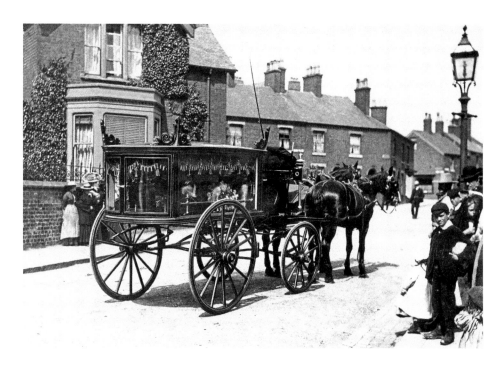

Horse-Drawn Hearse at Westwood Road, *c.* 1905

However modes of transport have developed over time, some people have always preferred their final journeys to be made by horse-drawn vehicle. This immaculate horse-drawn hearse stands in Westwood Road near the end of Barngate Street whilst onlookers await the loading of the coffin and departure of the cortège. Although no undertaker's name can be seen on the vehicle, it is almost certainly Samuel Sigley's as an identical vehicle, which is known to be theirs, appears in a different photograph.

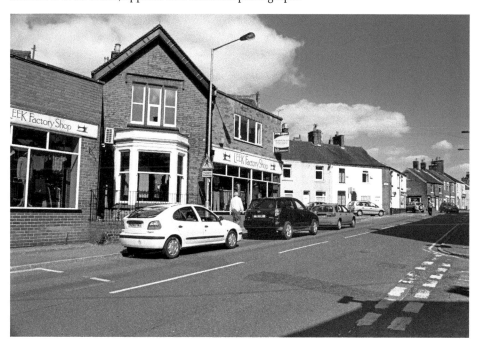

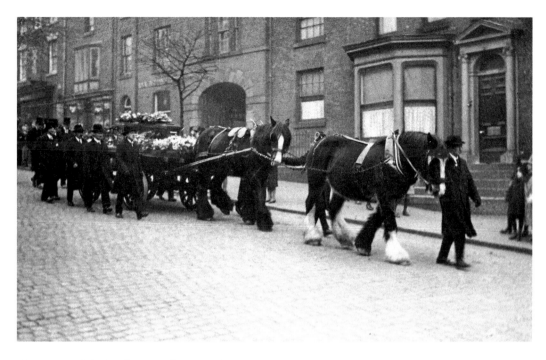

Sir Arthur Nicholson's Funeral Procession

Someone who made his last journey under horsepower was Sir Arthur Nicholson. He died in Bournemouth on 9 February 1929 and was returned to Leek by rail. On the day of his funeral, his coffin travelled from Highfield Hall to Leek Congregational church on a cart pulled by two of his own beloved shire-horses. From there the cortège went to St Edward's church, Cheddleton, where Sir Arthur was interred in the family vault. The old photograph shows the coffin travelling down St Edward Street.

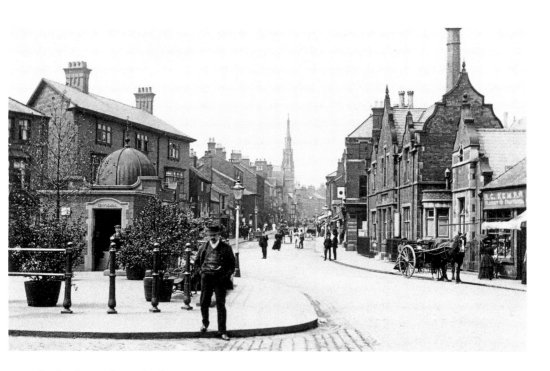

Derby Street from the Bottom

This photograph shows Sparrow Park at the bottom of Derby Street with its copper-domed public conveniences. Over time the roads that Leek Town Lands Trust allowed to cross the park became busy enough that a traffic island was developed on the site. This floral roundabout successfully managed traffic without major incident for eighty years until 2012, when Staffordshire County Council and SMDC decided to remove it despite a petition, an occupation and fierce and ongoing public protests against the decision.

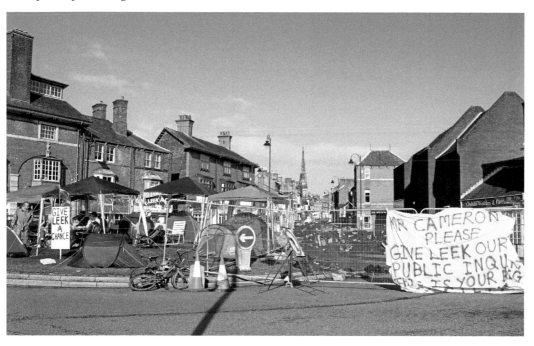

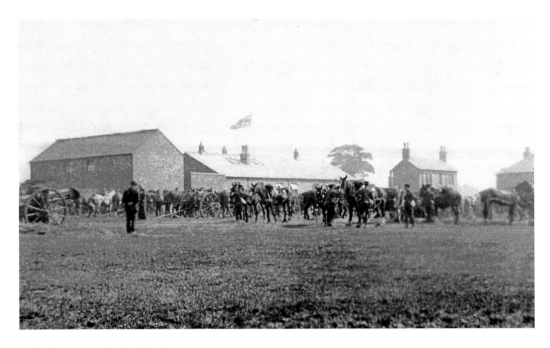

Leek Battery at the Drill Hall

This old photograph shows the 3rd Leek Battery at the Drill Hall in Alma Street, preparing for its departure to the war in France. Even a few days before they left there were still rumours that the battery might be going to Egypt rather than somewhere in Europe. The Drill Hall later became Adams Butter Social Club, and after it was demolished the area was built over, as per the recent photograph. The detached house in the distance is common to both photographs.

Leek Battery Passing along Belle Vue
Friday 14 August 1914 was the day when the
Leek 3rd Battery, with its four field-guns,
left Leek bound for the war in France. They
travelled along Frith Street to Belle Vue with
two policemen, followed by Major Challinor
and Lieutenant Arthur Falkner Nicholson,
leading. The previous year, George V and
Queen Mary had passed along Belle Vue when
visiting Highfield Hall, Lt Nicholson's parental
home, and Brough, Nicholson & Hall's mills,
presumably a much happier occasion.

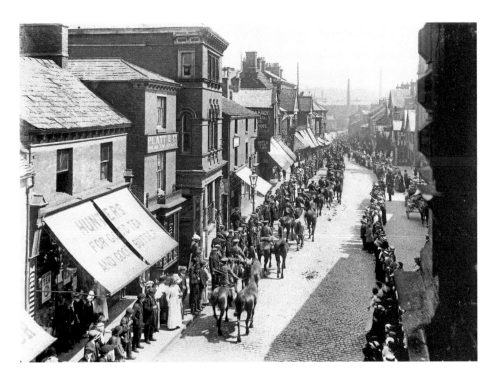

Leek Battery in Derby Street

The battery continued along West Street to Derby Street, where they were photographed from the upstairs of the Black's Head, now Yorkshire Trading. The recent photograph shows the somewhat happier occasion of an event intended to try and offset the effects of the recession coupled with the roadworks that seem unlikely to be encouraging people to visit Leek. Local bands played free of charge and vintage cars were displayed. Just out of sight is Anna Watkins' Olympic gold postbox.

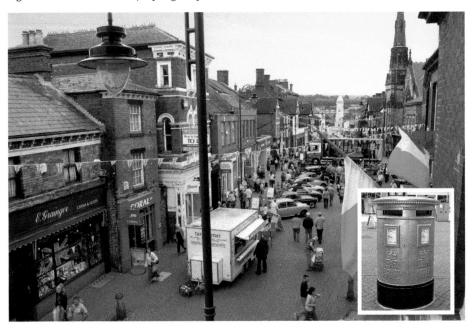

Leek Battery Passing Sanders Building

Here the battery is passing William Sugden's Sanders Building, occupied at the time by J. Mears, and even today this is still commonly known as Mear's Corner. Crowds line the route waving patriotically, but few could have anticipated the horrors that awaited their menfolk in France. Lieutenant Arthur Faulkner Nicholson, pictured, would be wounded in the shoulder, and that incident would be partly responsible for his brother Basil Lee being killed by a bullet through the head from a sniper.

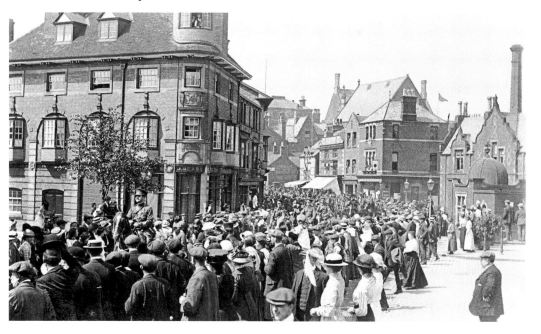

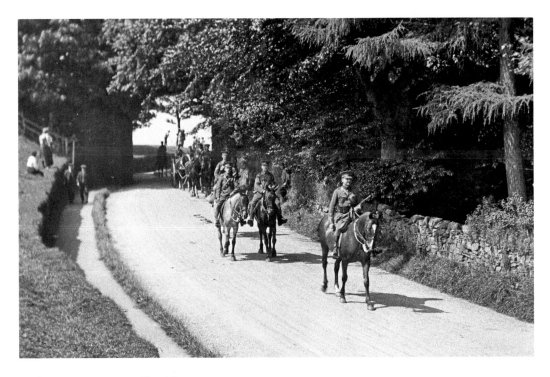

Leek Battery at Lowe Hill Bridge

At Lowe Hill Bridge, relatively few people watch the battery pass on its journey to Waterhouses. There it would rest briefly before proceeding to Ashbourne. Lowe Hill Bridge was rebuilt in 1960 to accommodate the larger vehicles of the time, but other than this the view has changed little over the past century. At the head of the column is Major Challinor looking every inch the senior officer, equipped with field glasses and his riding gloves, held in his right hand.

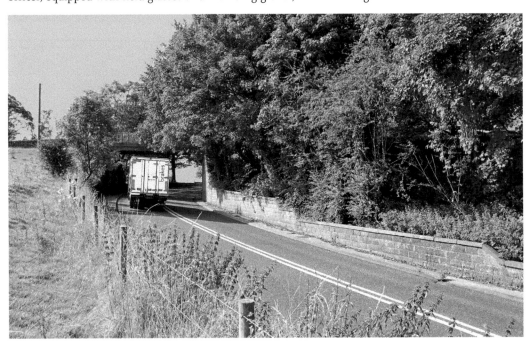

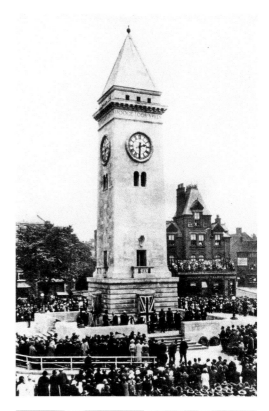

Dedication of Nicholson Memorial, 1925
The Nicholson War Memorial was commissioned by Sir Arthur Nicholson, in memory of his son Basil Lee Nicholson, killed in 1915 at Dranoutre, France. The Portland Stone memorial is 90 feet high but is not, as is often stated, the tallest war memorial in England. The three bronze plaques bearing the names of the fallen (including the author's great-grandfather) are covered by Union Flags awaiting unveiling. A ceremony in honour of the dead from the Second World War took place on 6 November 1949.

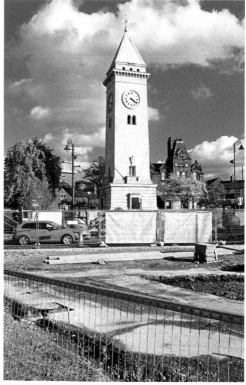

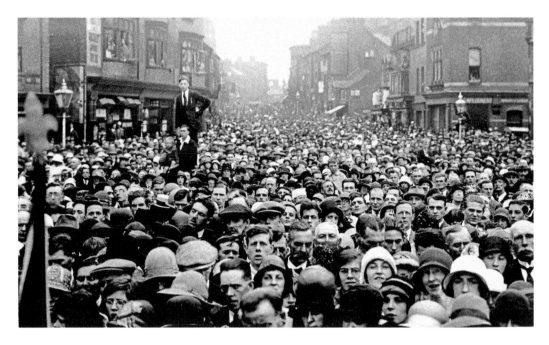

Crowd at Dedication Ceremony of War Memorial, Derby Street

On 20 August 1925, the war memorial known locally as 'The Monument', donated to the town by Sir Arthur and Lady Nicholson, was dedicated. The Great War had touched so many families that the town was packed with spectators. Crowds stretched all the way up Derby Street to Market Place and the other roads radiating from the monument were similarly congested. Through traffic on that day was probably as badly disrupted as by the roadworks taking place as this book is being prepared.

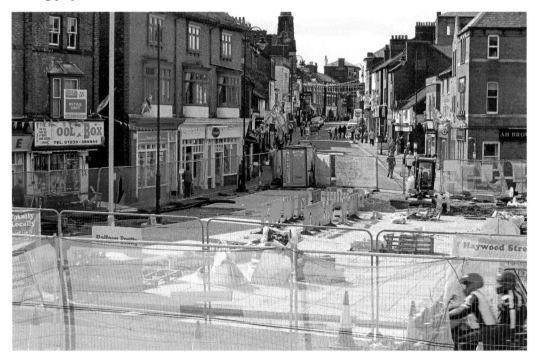

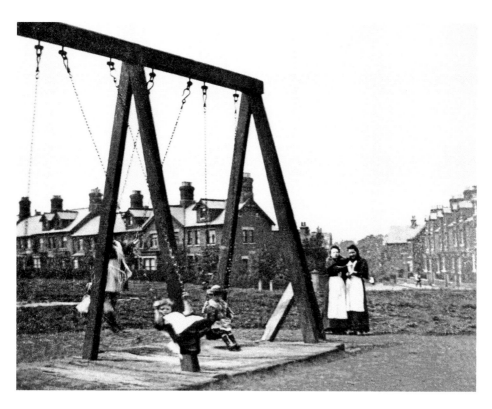

West End Recreation Ground, 1890s

This view looks across West End recreation ground towards North Avenue. The 'rec' was laid out in 1879 and this early photograph of children on the swings is probably from a series taken in the 1890s. The swings were clearly built to last, but despite that a new brace seems to have had to be added, presumably because one of the upright beams has started to split. You certainly wouldn't have wanted your toddler to be underneath had this structure collapsed.

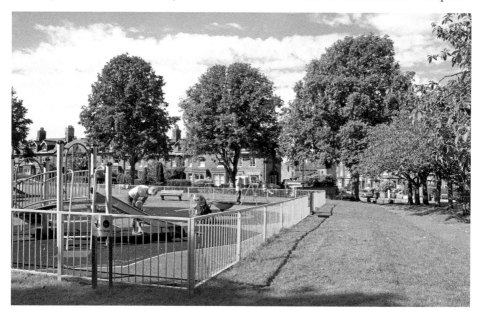

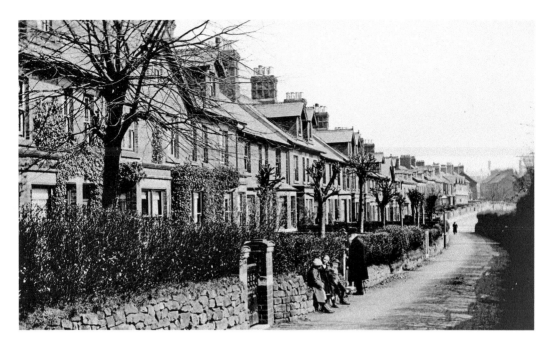

Westwood Road

This photograph shows Westwood Road as a narrow lane leading to Westwood Hall lodge, which still stands today. On one side are large, middle-class houses occupied in 1901 by professionals such as teachers, clerks and people living 'on own means'. On the opposite side is a bank topped by a hedge, marking the edge of the 'rec'. The white-bearded man in the overcoat looks every bit the respectable retired professional living on the money he has made after a lifetime in trade.

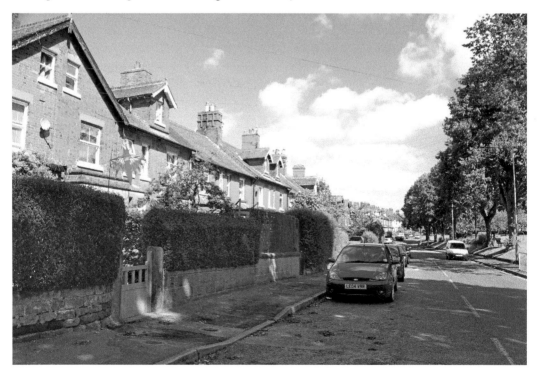

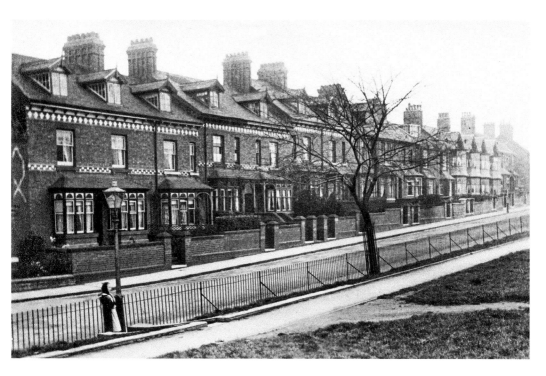

Westwood Road from the 'Rec'

This photograph, taken from the 'rec' lower down Westwood Road, shows the railings around the perimeter. These, together with railings from private houses, were removed during the Second World War, supposedly to melt down for weapons. There is a strongly held belief, though, that this was actually a propaganda exercise and that the railings were removed simply to strengthen feelings against the German enemy and bring the war to the doorsteps of those people not affected by events like the Blitz.

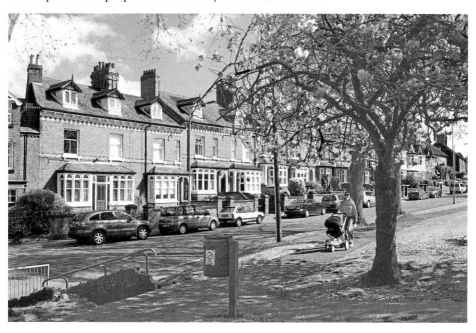

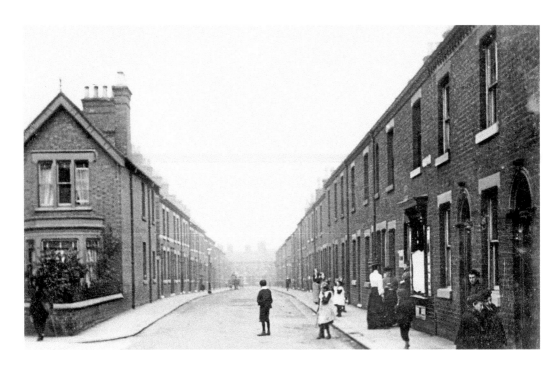

Grove Street

Grove Street is lined on both sides by unbroken terraced housing and it is probably a nightmare today for residents to find a parking space. Were it not for the exit along Jubilee Terrace, Grove Street would probably be the most stressful place in Leek for car-owners. In the old photograph the street looks wide and has a shop on the right-hand side. That shop is gone, and the 'Leek Factory Shop' on the left is also set to close soon.

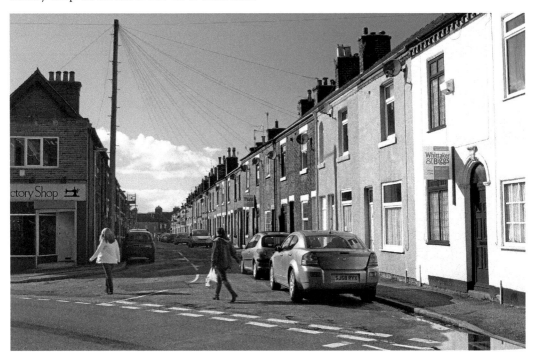

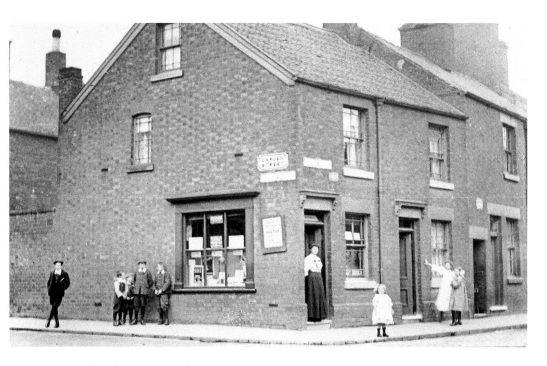

Corner of Garden Street and West Street

It is not immediately clear what this shop was, but it may have been a chip-shop, something supported by the two signs advertising Midland Vinegar visible above the door. Today it is Take-a-Break, which does a brisk trade selling English takeaway food, including the north Staffordshire delicacy of oatcakes filled with bacon and cooked cheese. To the left is a house in West Street's Court No. 8, one of three that were reached through the low door to the right.

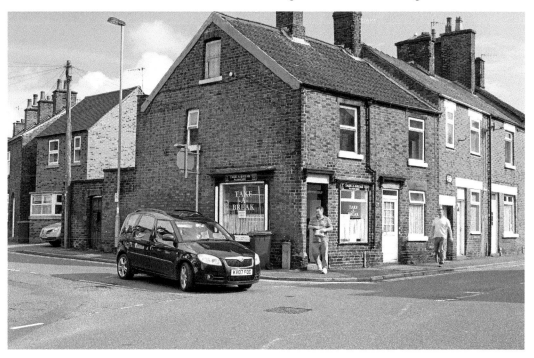

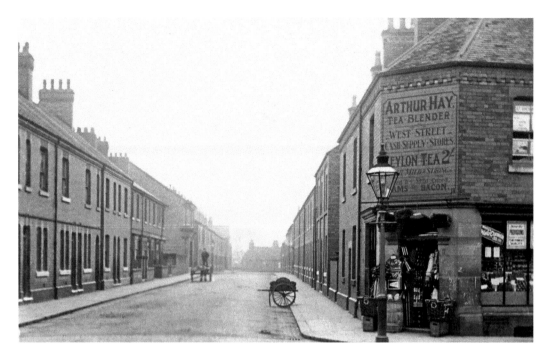

Arthur Hay's Shop, West Street

At 45 West Street, Arthur Hay describes himself, in very large lettering, as a tea-blender and yet he also advertises hams and bacon and clearly also sells Hudson's soap, butter and a wide selection of brushes. Very carefully displayed in Picton Street is Arthur's delivery cart, no doubt powered by a young lad. Today the shop is John Grimes' J&J greengrocers but has also recently been a motorcycle showroom, a wallpaper shop and a hair and beauty salon.

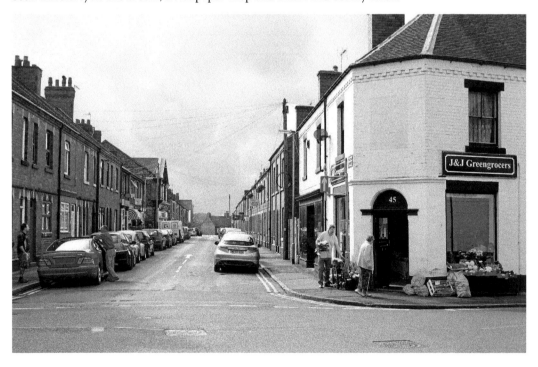

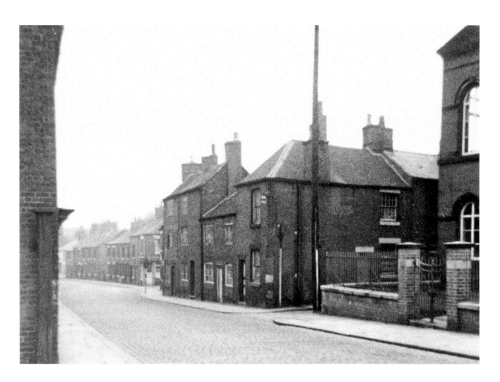

West Street, 1960

The modern photograph taken from next to the imaginatively named Curl Up & Dye hairdresser's shows the changes that have occurred in this part of West Street. In the old photograph the entire road is still cobbled, those cobbles still remaining under today's tarmac. The block of buildings next to the Britannia have gone, replaced by an extension to the Britannia and a council car park. School Street survives but now has no street sign and no inhabitants.

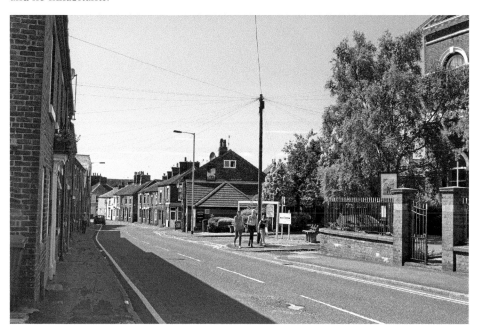

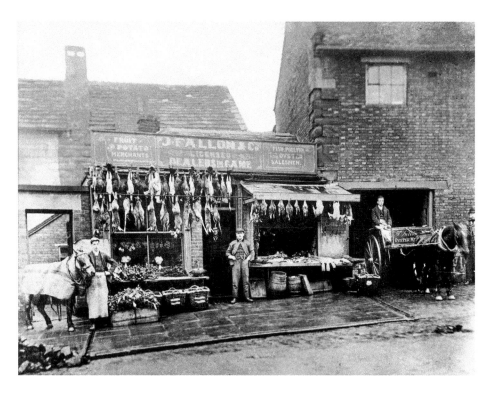

John Fallon's Shop, Stockwell Street

John Fallon was working as a fishmonger in Leek in 1881 when he lived in Britannia Street with his wife and young son William. By 1891 John had his own fish, game, fruit and vegetable shop at No. 7 Stockwell Street (pictured). By 1901 he had moved to Derby Street, next door to John West's Ironmonger's (see page 76). By then William had left home and opened his own remarkably similar-looking shop in St Edward Street (see following photograph).

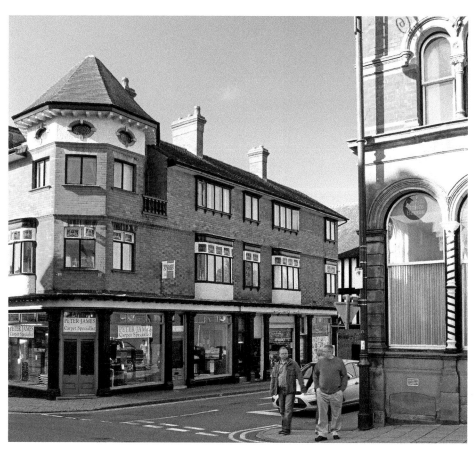

William Fallon's, St Edward Street

William Fallon opened his own shop selling game, fish, vegetables and fruit, *c.* 1900. The building to the right in both photographs used to be the Westminster Bank and is today called Bank House. Fallon's shop therefore stood where the end of High Street is today. When Field House was sold, its land was used to create High Street, involving the demolition of Fallon's and the Globe Public House. Field Street was also created before 1911 on Field House land.

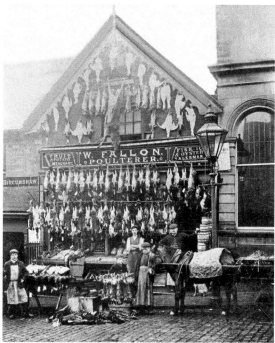

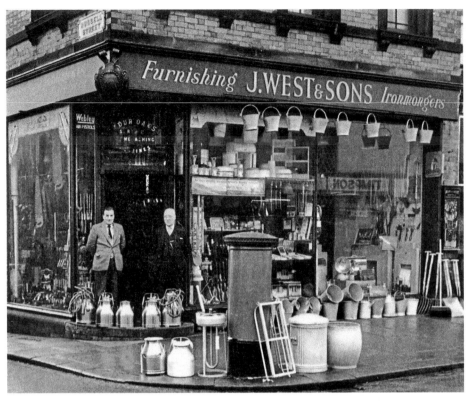

John West's Shop, Derby Street
In 1881, John West was a twenty-year-old ironmonger's assistant in Ralph Wooliscroft's shop on the corner of Russell Street and Derby Street. Ten years later West had done very well for himself, having bought the shop, married and produced two children. Also living with him and his family were his cousin, two boarders and two servants. The shop was ostensibly an ironmongers but also sold sporting goods, including Webley air-pistols, ceramic fire surrounds, oil, paint and portable milking machines!

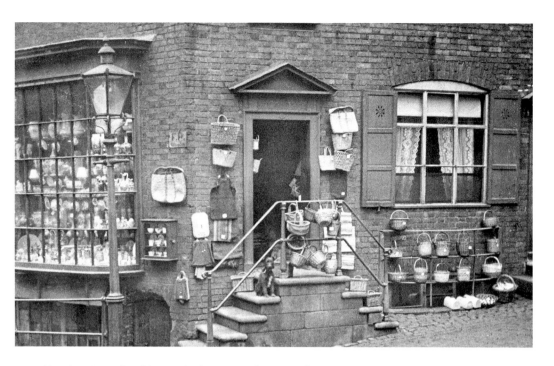

Harriet Harrod's China and Glassware Shop, Stanley Street

How much is the doggy on the step? Perhaps it doesn't have the same ring as the well-known song but Harriet Harrod's shop did stand on the corner of Dog Lane and Stanley Street, with access to the shop via a set of steep stone steps. The shop sold baskets, glassware and china. Although the cellar probably still exists, there is no sign of it now from the outside. Carney's solicitors have now vacated the premises and it presently stands empty.

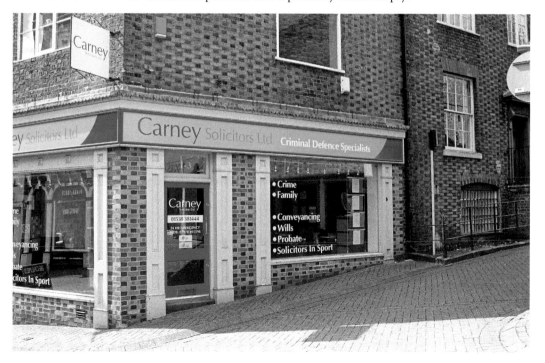

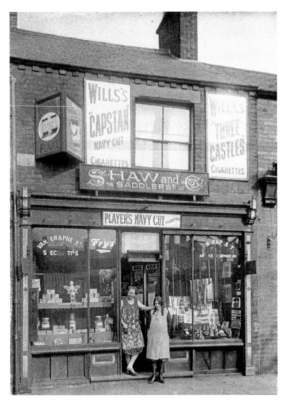

Shaw & Company Saddlers, Haywood Street

This photograph shows Pauline Fisher and her mother Alice standing on the step of Shaw's Saddler's. It appears from this shot that the shop is already devoting more effort to selling tobacco and sweets than saddlery. Later Tom Fisher ran the shop as a tobacconist's and also served cups of tea to the bus-drivers bringing hundreds of millworkers to Leek every day from the Potteries. The shop is now George Gunia's jewellers, run by George's son John and his partner.

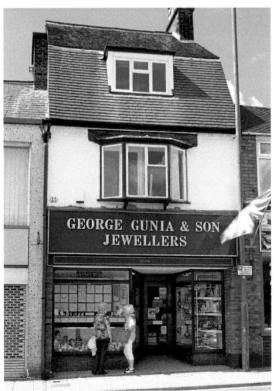

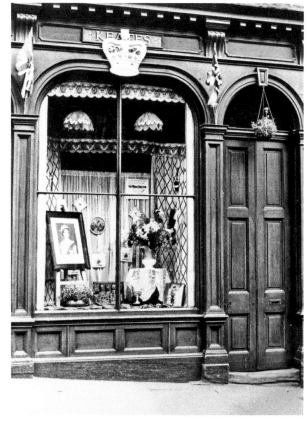

Keates' Wool Shop, Stanley Street, 1953

Keates' Wool Shop was photographed in 1953, celebrating the Coronation of our present Queen. Wooden arches were fashioned and erected all over the town, streets were decorated with bunting and shops created special Coronation window-displays like this one. When knitting was a common activity producing usable practical clothing at low prices, every town had its wool shop(s), but today Leek no longer has a wool shop at all, instead Flashback sells a variety of 'retro' items and gifts.

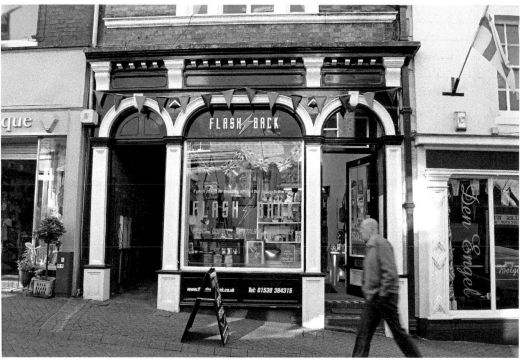

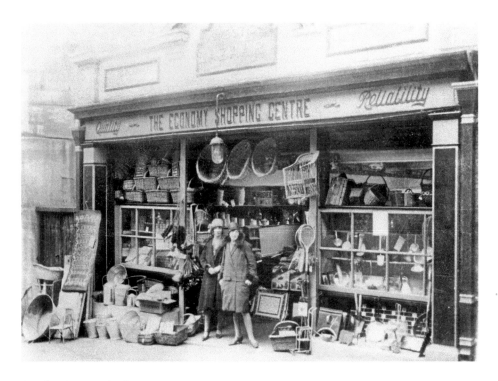

Stanley Street, The Bazaar, *c.* 1930

The Domestic Bazaar or Economy Shopping Centre in Stanley Street offers 'Quality' and 'Reliability' and appears almost like a modern-day Wilkinson's. The windows and pavements outside are stuffed with all manner of goods: baskets, garden tools, tennis racquets and buckets to name but a few. Things are not always what they seem, though; behind the solid-looking Art Deco frontage the shop, now Breckles Health Food shop, has a corrugated-iron roof. The author shopped here for pocket-money toys as a child.

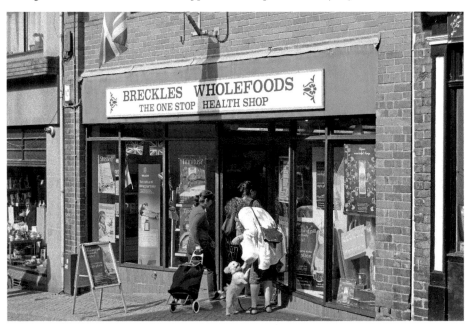

Star Supply Stores, Market Place

The proprietor of the Star Supply store seems to be adopting a pose offering customers a good hiding rather than a good deal. His merchandising policies seem to be 'stock everything' and also 'pile 'em high 'n' sell 'em cheap', perhaps the forerunner of today's supermarkets. To the left of the shop can be seen part of the small shop on the right-hand side of the Butter Market entrance. When Argos moved to Pickwood Road this shop became half of Thornton's Chocolate/Hallmark Cards.

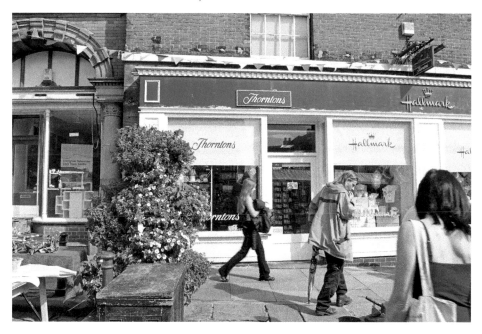

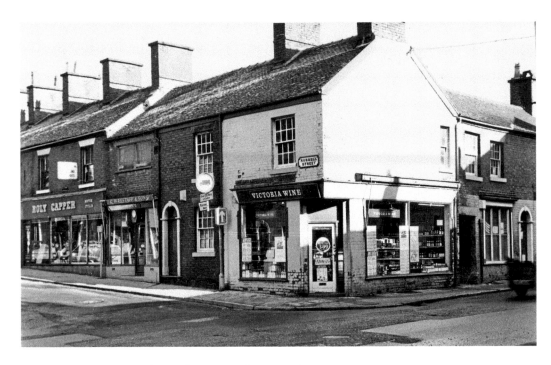

Victoria Wine, Corner of Russell Street and Haywood Street

The Victoria Wine shop at the bottom of Russell Street was probably built around 1860, indicated by the house doorways on either side. The shop has been photographed in various different guises, as Charles W. Bott's grocers shop, as a bicycle shop and as Victoria Wine. The shop and its neighbours were presumably demolished to allow the street to be widened as there is now only one, brand-new, shop between Roly Capper's motorcycle showroom and Haywood Street.

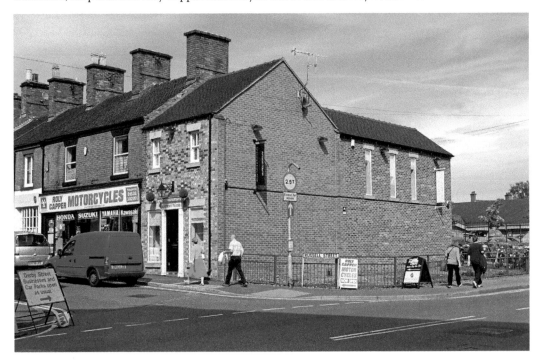

Tatton's Bakers, Derby Street
J. H. Tatton's moved into the building next to the Roebuck Hotel in Derby Street in 1908. Theirs was a high-class bakery and café and they later made a decision to apply false timber framing to the front of the building to make it blend in better with its seventeenth-century neighbour. When Tatton's was demolished, the building that replaced it was also intended to reflect the form of the Tudor building – but probably the less said about that the better.

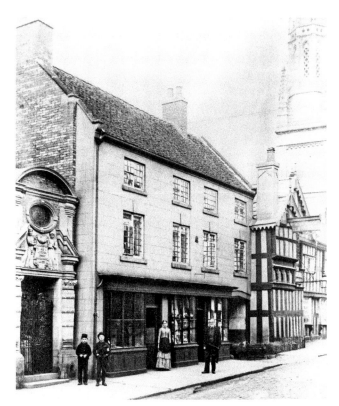

Shops Awaiting Demolition, Ashbourne Road

This row of early-nineteenth-century shops stood just above the Talbot Hotel on Ashbourne Road until relatively recently. The second shop from the left used to house Allan Poyser's gent's hairdressers, where Allan's daughter Linda (Wassall) trained as a barber. Linda still runs Poyser's, which used to be her grandfather's hairdressing shop in Sheepmarket. Interestingly, a relative ran another Poyser's barbershop in far-off Manchester – all in all, quite a hairdressing dynasty.

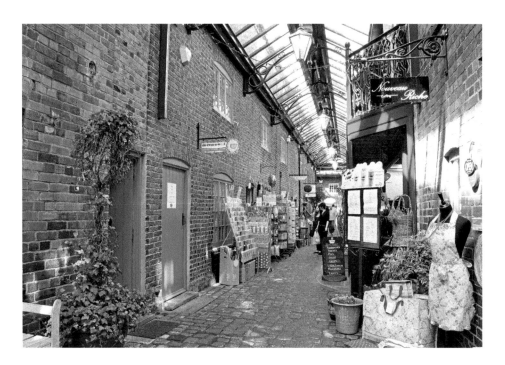

Getliffe's Yard

At the end of the nineteenth century, Leek's Improvement Commissioners stated that Getliffe's Yard consisted of nothing but brothels and doss-houses – officially 'lodging houses'. Later, three cottages were knocked together by Fred Hill to carry out his printing operations in. These were presumably the three in the old photograph that have been re-pointed and bear the sign Getliffe's Design and Print. Today, as the recent photograph shows, the yard has been transformed into a stylish shopping arcade with a glazed roof.

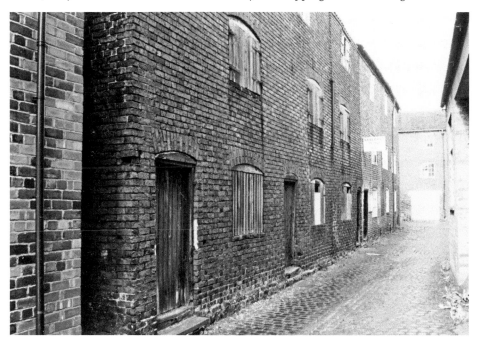

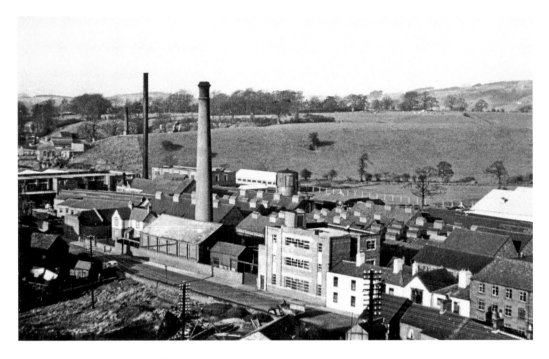

Churnet Works from the Old Parade Ground, c. 1938

The old photograph shows 'Churnet Works' when it was a hub of industry. The recent photograph shows the new supermarket development on the site, involving the relocation of small firms into new industrial units and the building of houses as well as the supermarket itself. This development has dictated sweeping changes to Leek's road system, something that many Leek people feel aggrieved about and which during the recession of 2012 has done nothing to assist local trade around the town.

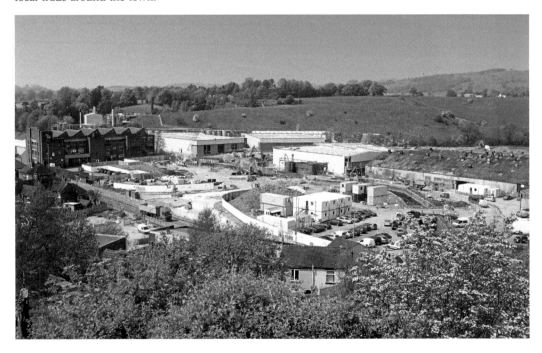

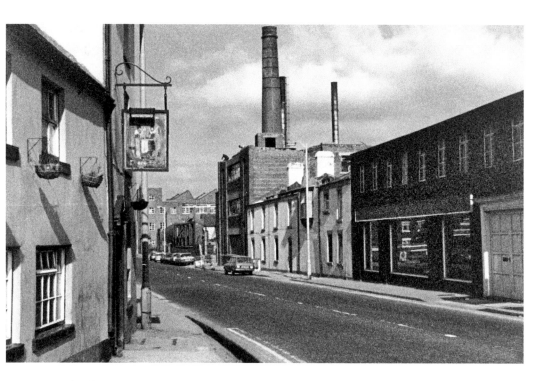

Towards Churnet Works from the Dyers Arms

This photograph, taken from the bottom of Kiln Lane, looks past the Dyers Arms towards T. & A. Wardle's Churnet Works print-room building. It shows the beginning of demolition of buildings on the site, some old and some much newer. To the right can be seen David Scott-Moncrieff's Rolls-Royce showroom, only demolished within the last year as part of the new supermarket development. The company described itself as 'Purveyors of Horseless Carriages to the Nobility and Gentry since 1927'.

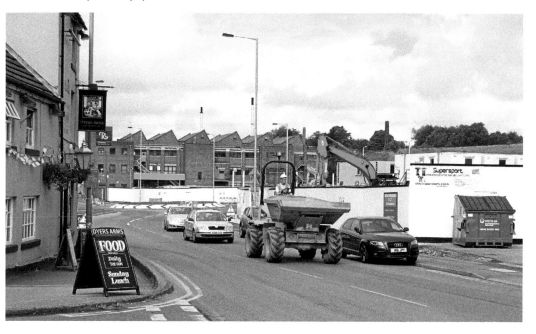

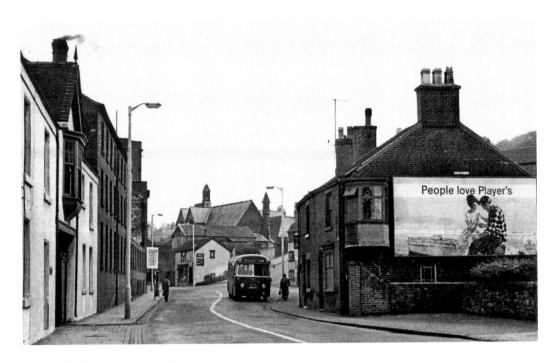

Macclesfield Road Towards Belle Vue

This photograph shows the opposite view from the previous one and was taken somewhat earlier when the buildings, now on the left, were still in use. To the right can be seen a row of houses that used to be attached to the Dyer's Arms but have since been demolished. Also visible are shops on either side of the bottom of Belle Vue Road. Next to the white-painted nineteenth-century building is a large building yet to be converted to Scott-Moncrieff's showroom.

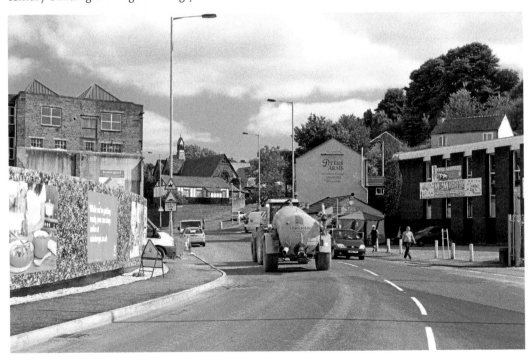

Kiln Lane

Kiln Lane has probably been in existence since the thirteenth century, when it formed part of a path between Dieulacres Abbey and one of the abbey's granges (sheep-grazing) at Westwood. To the right of both photographs is Rock Villa, built *c.* 1865 and former home of Henry Wardle, who had previously kept the Britannia Inn in West Street. Wardle was one of the founders of Wardle & Davenport and by the age of forty-eight was described as a retired silk manufacturer.

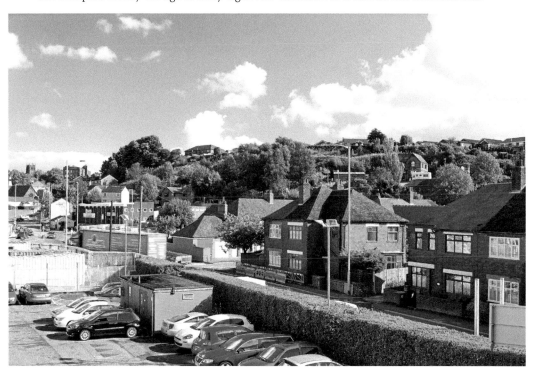

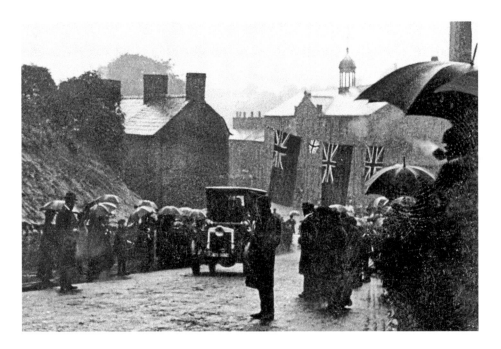

Opening of Belle Vue Road, 13 September 1906

On 13 September 1906 a new, widened road was opened between the junction of Mill Street/Macclesfield Road and the end of the existing Belle Vue. Part of the old cobbled road, known locally as Kingsway, still survives. The new road was designed to act as a shortcut between Macclesfield Road and the railway station. It is said that this was to allow traffic to avoid the climb up Mill Street but there is probably no steeper incline in Leek than Belle Vue Road!

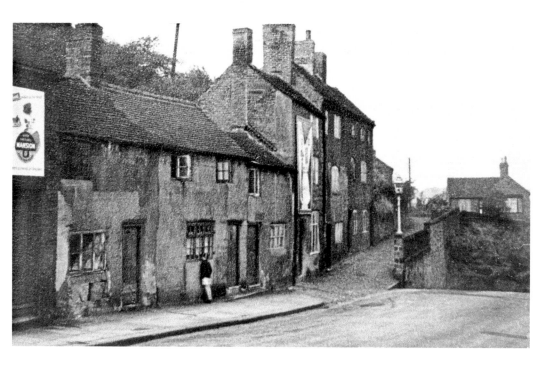

Belle Vue and Back Lane

This photograph shows some of the cottages that used to stand on the left side of Belle Vue Road. It also shows Back Lane, joining Belle Vue Road to Kiln Lane. Today only the bungalow on the right of Back Lane survives, the cottages having been replaced by two blocks of flats. One of the posters visible in the old picture advertises Mansion Polish and the other is for a military tattoo; the same poster appears on a photograph of Mill Street.

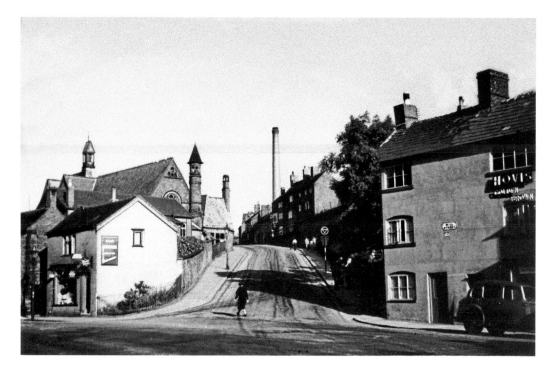

Belle Vue from Mill Street

Another Mill Street-area photograph showing Belle Vue Road from Mill Street. Why anyone could imagine that this road was opened to provide a safe and easy alternative to Mill Street is a mystery. It is possibly more suited as an alternative to the Cresta Run in St Moritz, as it must be highly hazardous even today in icy conditions. Virtually everything shown in this photograph has been demolished, the notable exception being St John's church, and even that has been altered.

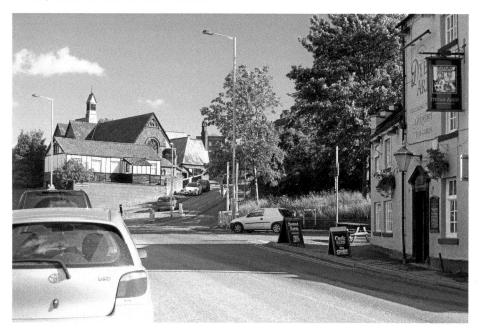

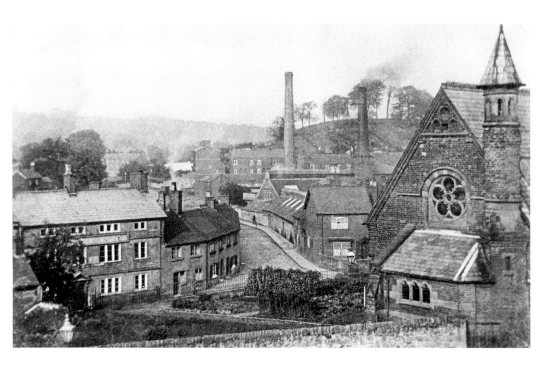

View from Belle Vue to Abbey Green Road

These photographs show the much-altered view from Back Lane, looking over Belle Vue Road towards Abbey Green Road. The old photograph shows Hencroft Dye Works, now largely demolished, and beyond it Inkermann Terrace. In the middle ground stands 'The Dog and Rot', properly called Leek Conservative Working Men's Club, one of only a few such in the country. The cottages next to the club have been demolished and the 'spire' from St John the Evangelist's church has also now been removed.

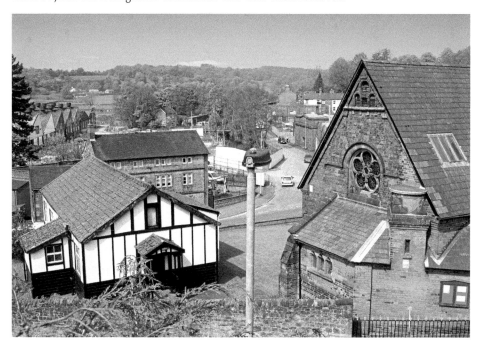

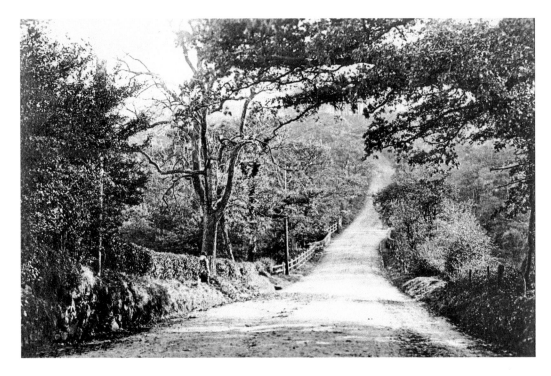

Solomon's Hollow

Probably not a popular photographic subject today, Solomon's Hollow on the Buxton Road is a deep valley, probably hated by amateur cyclists who rocket down into it and then come to a fairly rapid, wobbling halt as they try to pedal out again. It causes few problems to today's motor-cars but has seen some serious accidents and at least one fatality when speeding drivers have been caught unawares by its steepness and the bend at the bottom.

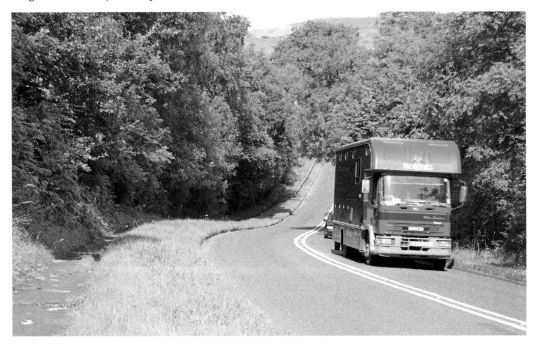

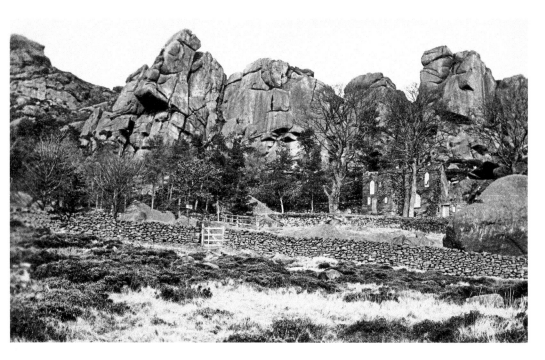

The Roaches, Rock Hall

Rockhall Cottage was built in 1850 by the Brocklehurst family of Swythamley Hall to house the estate gamekeeper. It later became famous as the home of Doug Moller, self-styled 'Lord of the Roaches', and his wife Anne, who bought the cottage for £6,000 at auction in 1978. The Mollers moved out in 1989 and in 1992 the cottage was restored and modernised for use as a climbing hut. Until then it had had no toilet, bath, electricity, gas or running water.

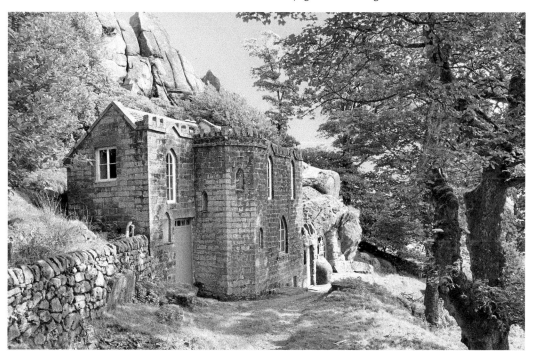

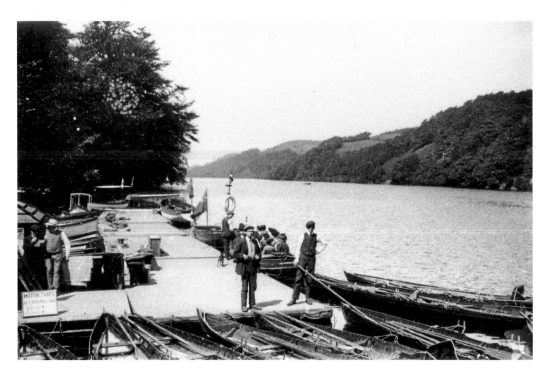

Edwardian Boaters, Rudyard Lake

Rudyard Lake was begun in 1797 to feed water to the network of canals so vital in transporting goods during the industrial revolution. During the Victorian age it was a popular tourist attraction and in 1863 John L. Kipling met Alice Macdonald at a picnic party there. Two years later they had married and emigrated to Bombay, India, where Alice gave birth to a son whom they called Joseph Rudyard. He would go on to achieve huge fame as Rudyard Kipling.

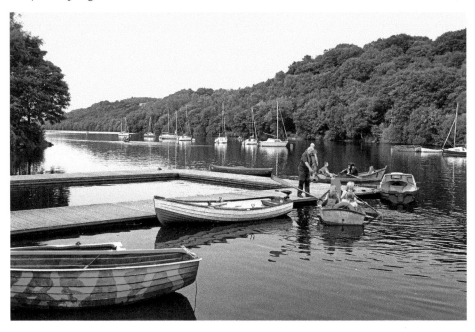